THE MAINE LOBSTER INDUSTRY

A HISTORY OF CULTURE, CONSERVATION & COMMERCE

CATHY BILLINGS

Published by The History Press
Charleston, SC 29403
www.historypress.net

Copyright © Cathy Billings
All rights reserved

All photos courtesy of the author unless otherwise noted.

First published 2014

Manufactured in the United States

ISBN 978.1.62619.410.6

Library of Congress CIP data applied for.

Notice: The information in this book is true and complete to the best of our knowledge. It is offered without guarantee on the part of the author or The History Press. The author and The History Press disclaim all liability in connection with the use of this book.

All rights reserved. No part of this book may be reproduced or transmitted in any form whatsoever without prior written permission from the publisher except in the case of brief quotations embodied in critical articles and reviews.

About the Author

While the name Billings is well known in Maine's lobster community, particularly in the Stonington–Deer Isle area, I must confess I am not a native Mainer. My father was from Mineola, New York—out on Long Island—and my mother was from Baltimore, Maryland. They met on a blind date when my dad was attending Annapolis and married shortly after he graduated and received his naval commission. I was born in California, the fourth of five children. My family moved to Maine when I was four, and I have lived in Maine ever since. I grew up in South Berwick, just a stone's throw from the Kittery Navy Yard, where my dad worked, and just a short drive from the beaches of York and Ogunquit. Though I've been here fifty-three years, by Maine standards, I'm still "from away." In my heart, though, I am a Mainer through and through. I attended the University of Maine, graduating with a degree in education in 1978 and a master's in public administration in 1995. I worked in the floral business for ten years before starting my career at the University of Maine, where I held several positions before landing at the Lobster Institute as the associate director for communications and development. It's hands down the best job I've ever had. The men and women I've met in the lobster industry continually impress and amaze me with their work ethic, their knowledge and their commitment to making the lobster industry in Maine a model of sustainability and a heritage of which to be proud.

V

value-added products 67, 90, 96
V-notch 42, 76, 78, 79

W

Weymouth, Captain George 15, 16, 30, 36
wire traps 37

Z

zones 39, 75, 82

Index

G

gear 13, 36, 41, 44, 90, 109

H

habitat 84, 87, 96, 106
hard-shell 20, 60, 69
hatcheries 84, 86
hoop net 36

I

imports 68

J

juvenile 19, 82, 84, 86

L

landings 55, 57, 60, 61, 67, 69, 76, 83, 101, 102
larvae 19, 87
live lobster 47, 48, 50, 51, 59, 60, 63, 65, 68, 101, 105
lobster bake 109
Lobster Institute 7, 8, 11, 13, 23, 25, 33, 37, 46, 55, 77, 93, 94, 95, 101, 110
lobster roll 65, 67, 107
Long Island 24, 85, 96

M

Maine Lobstermen's Association (MLA) 8, 11, 73, 74, 77, 88, 93
management 12, 13, 39, 70, 72, 73, 74, 75, 82, 87, 88, 90, 91, 92
marketing 20, 59, 60, 88, 101, 102, 103, 104, 105
Massachusetts 25, 31, 37, 39, 67, 68, 94, 95
measuring 42, 46, 70, 76, 78, 82, 96
molt 19

N

NMFS 72, 73

P

peapod 31, 32
processing 48, 51, 59, 61, 65, 67, 69, 70, 71, 88, 90, 96

R

railroads 27
regulations 12, 39, 68, 72, 75, 82, 83, 88, 90, 91, 93, 103

S

science 13, 78, 90, 92, 94, 100
Sea Grant program 93, 94
shedders 70
shipping 13, 17, 25, 27, 29, 54, 59, 63, 68, 90, 104, 105
size 19, 34, 42, 50, 70, 90
smack 24, 25
soft-shell 20, 26, 46, 60, 65, 69, 104
sternmen 12, 21, 22
stock assessments 90
storage 26
sublegal 81, 82
sustainability 50, 71, 75, 76, 88, 89

T

tidal lobster pound 12, 86
tourism 12, 106
traps 9, 10, 11, 12, 20, 21, 23, 32, 34, 35, 36, 37, 39, 41, 42, 44, 46, 50, 55, 56, 74, 75, 76, 79, 81, 82, 83, 84, 85, 104, 109, 116
trawls 32, 35, 41

U

University of Maine 7, 8, 11, 13, 46, 73, 77, 93, 94, 95, 96

Index

A

Acheson, Dr. James 8, 60, 77, 78, 96
ASMFC 73

B

bait 11, 12, 16, 21, 30, 36, 37, 44, 46, 55, 56, 58, 59, 79, 81, 83, 84, 100, 109
banding 22, 41
Bayer, Dr. Bob 7, 46, 77, 94, 95, 96, 112
boat price 46, 55, 56, 57, 58, 61, 67, 73, 105
boats 12, 13, 15, 22, 23, 30, 32, 33, 34, 36, 41, 42, 44, 46, 55, 56, 57, 58, 61, 67, 73, 79, 87, 88, 100, 101, 104, 105, 109
buoy 31, 33, 35, 41, 79, 82, 87

C

Canada 17, 23, 37, 41, 42, 44, 51, 61, 63, 68, 69, 70, 71, 78, 84, 86, 93, 94, 95, 104
canning 48
China 51, 68, 105
claws 17, 50, 104

conservation 12, 42, 50, 72, 76, 78, 79, 82, 83, 87, 88, 93
co-op 57, 58, 59, 60
cooperative. *See* co-op

D

dealers 12, 24, 26, 27, 29, 36, 44, 46, 55, 57, 58, 59, 60, 61, 65, 73, 74, 75, 88, 91, 103, 105
distributors 7, 12, 29, 59, 63, 88, 104
DMR 39, 41, 73, 74, 91, 105
dory 30, 32
Downeast 8, 32, 74, 86, 107

E

eggs 19, 42, 76, 78, 86, 107
equipment 21, 35, 36
Europe 24, 26, 29, 49, 51, 63, 68
exports 68, 93

F

festivals 103
frozen lobster 44, 51, 65, 67, 70, 71

Glossary

PEAPOD: An open, double-ended boat used for fishing in Maine.

SHALLOP: A small, open boat fitted with oars and sails for use in shallow waters.

SHEDDERS: Soft-shell lobsters that have just recently molted. Also called "new-shell."

SKEG: A boat in which the hull goes flat into the keel. Skeg-model boats are often faster, as there is less holding the hull back with the very flat run aft.

SMACK: A vessel with an open well built into the hull to store lobsters during transport.

SMACKMAN: One who operates a smack.

SOAK TIME: The length of time between setting a trap in the water and then hauling it back up.

STERN: The aft, or back end, of a boat.

STERNMAN: A person who works on a lobster boat to help a licensed lobsterman with any task other than the hauling of traps.

SUBLEGAL: A lobster brought up in a trap that is below the minimum size allowed by law.

TRAWL: Two or more traps strung together.

V-NOTCH: *n.* A cut in the shape of a "v" on the tailfin of a lobster indicating that the lobster is a female capable of bearing eggs; *v.* the act of putting a V-notch on a lobster, followed by returning it to the ocean (used as a conservation measure).

WHOOPIE PIE: A Maine bakery treat made with two pieces of cake (traditionally chocolate) that are flat on the bottom, mounded on top and sandwiched together with a creamy filling.

Glossary

DOWNEAST: The stretch of coastal Maine from Penobscot Bay to the Canadian border; derived from sailing terminology, when vessels would take advantage of prevailing southwest winds to travel "downwind" to the easternmost parts of the Maine coast.

EGGERS: Lobsters that are carrying eggs on the underside of their tail.

EGG-OUT: The act of a lobster extruding its eggs to the outside to be carried on the underside of its tail.

GAFF: *n.* A stick with an attached hook used to catch hold of a buoy line in order to pull it up to the boat for hauling (or a barbed spear for landing large fish); *v.* to hook with a gaff.

HAUL: The act of pulling a trap from the water.

HAULER: A hydraulic pulley system on which a trap line is attached to haul a trap onto the boat.

HOG RING: A type of clip used to fasten together parts of a lobster trap. Also the circular ring that holds open the netted head of the lobster trap.

HOOP NET: A cylindrical net supported by one or more hoops and fitted with one or more valves resembling funnels through which fish may enter but not escape.

KITCHEN: The first inner compartment of a lobster trap that the lobster enters.

LARVAE: The term used to describe lobsters from the period immediately following hatching to Stage IV, when they are heavy enough to sink to the bottom to find shelter.

LATH: A thin, narrow strip of wood used to build traps.

MOLT: The process of a lobster shedding its shell in order to allow for growth.

PARLOR: The second compartment within a lobster trap (sometimes called the bedroom), entered through the kitchen.

Glossary

BANDING: The act of placing rubber bands over the claws of a lobster to prevent them from opening and closing.

BEDROOM: See "parlor."

BENTHIC: Of or dwelling on the floor of the ocean.

BOAT PRICE: The amount paid per pound to a lobsterman when he brings his catch to the dealer.

CARAPACE: The part of a lobster's shell that makes up the body (from just behind the eyes to the start of the tail).

COOPERATIVE: A group of lobstermen who band together to sell their lobsters without using a dealer; also called a co-op.

CRUSTACEAN: An invertebrate animal with several pairs of jointed legs, a hard protective outer shell, two pairs of antennae and eyes at the ends of stalks.

DORY: A flat-bottomed boat with high flaring sides, a sharp bow and a deep V-shaped transom.

Chapter 8

25. Maine Lobstermen's Association, "MLA: The First 50 Years," http://mainelobstermen.org/pdf/MLAfirst50years.pdf.
26. James Acheson and Roy Gardner, "The Evolution of the Maine Lobster V-Notch Practice: Cooperation in a Prisoner's Dilemma Game," *Ecology and Society* 16, no. 1, http://www.ecologyandsociety.org/vol16/iss1/art41.
27. Jonathan Grabowski et al, "Use of Herring Bait to Farm Lobsters in the Gulf of Maine," http://www.ncbi.nlm.nih.gov/pmc/articles/PMC2855364.
28. Mike Crowe, "Maine Lobster Certification: The Nuts and Bolts," *Fishermen's Voice* (April 2009).

Chapter 9

29. Maine DMR, http://www.maine.gov/dmr.
30. Northeast Consortium, http://www.northeastconsortium.org.

Chapter 11

31. The PEW Charitable Trusts, http://www.pewenvironment.org.
32. Longwoods International, "Travel and Tourism in Maine: The 2004 Visitors Study Management Report," www.econdevmaine.com/resources/pdfs/visitor_study_2004_mgmt_report.pdf.
33. Maine Lobster Festival, "Our History," http://www.mainelobsterfestival.com/about/our-history.

Notes

Chapter 4

11. Maine DMR, http://www.mainelegislature.org/legis/statutes/12/title12sec6421.html.
12. SeadoryPlans.com, "History of Dory Boats," http://seadoryplans.com/14/history-of-dory-boats.
13. Maine Boats, Homes and Harbors, "Evolution of the Maine Lobsterboat," https://www.maineboats.com/online/boat-features/evolution-maine-lobsterboat.
14. Joel White, "Maine Coast Peapod," http://www.artisanboatworks.com/classic-designs/rowboats/maine-coast-peapod.
15. Christina L. Oragano, *How to Catch a Lobster in Down East Maine* (Charleston, SC: The History Press, 2012).
16. Lowell Brothers, "Frost-Lowel Boatbuilding Timeline," http://www.lowellbrothers.com/boatbuilding-timeline.htm.
17. Virginia Thorndike, *Maine Lobsterboats* (Rockport, ME: Downeast Books, 1998).
18. Gulf of Maine Research Institute (GMRI), "A Socio-Economic Survey of New England Lobster Fishermen," http://www.gmri.org/upload/files/gmri_lobster_report_lores.pdf.

Chapter 5

19. Townsend, *Lobster*.
20. Harry L. Sanborn, "The Biennial Report of the Department of Sea and Shore Fisheries," Rockland, ME, 1918.
21. Lobstermen of Downeast Maine.

Chapter 6

22. Acheson, *Lobster Gangs of Maine*.
23. Maine DMR, http://www.maine.gov/dmr.
24. Virginia Wright, *The Maine Lobster Book* (Rockport, ME: Downeast Books, 2012).

Notes

Chapter 1

1. Ronald Banks, *A History of Maine: A Collection of Readings on the History of Maine, 1600–1974* (Dubuque, IA: Kendall Hunt, 1974).
2. Ibid.
3. Ibid.
4. Elisabeth Townsend, *Lobster: A Global History* (London: Reaktion Books, 2011).
5. Lobster Institute, www.lobsterinstitute.org.
6. Ibid.
7. Ibid.

Chapter 3

8. James M. Acheson, *The Lobster Gangs of Maine* (Lebanon, NH: University Press of New England, 1988).
9. Ibid.
10. Arthur S. Woodward, "A 1950s Trip in a Lobster Smack," http://umaine.edu/lobsterinstitute/files/2011/12/Trip-in-a-Lobster-Smack.pdf.

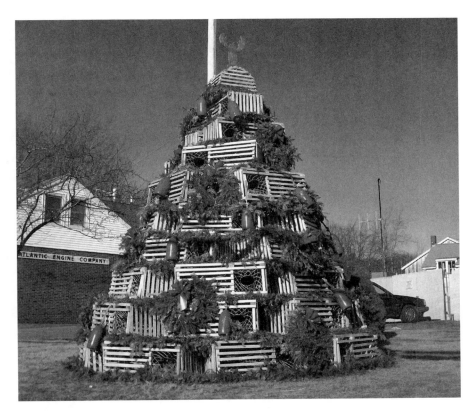

The lobster trap Christmas tree in Cape Porpoise.

square during the holidays, one might even find a lobster-themed Christmas "tree"—perfectly stacked lobster traps draped with fresh garland made from Maine fir trees, colorful buoys serving as ornaments, and strung with lights for a nighttime sparkle.

Lobsters are a culinary delight, a work of art and the mainstay of one of the longest-standing industries in Maine's history. Maine invites everyone to come and enjoy its plentiful harvest from the sea and share in its great lobstering heritage, which, if history indicates, is destined to continue for many years to come.

A History of Culture, Conservation and Commerce

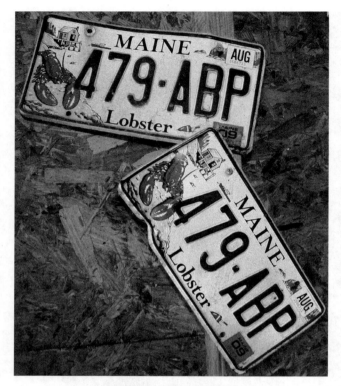

Opposite, top: Carved lobster art.

Opposite, bottom: Matt Hodgkin (left) and author Cathy Billings (right) poke their heads through lobster cutouts at Mc's Market in Gouldsboro. *Courtesy of a visiting tourist with New York license plates who kindly took this picture with my camera.*

Left: Maine lobster license plates.

Below: Motorists are urged to use caution at lobster crossings.

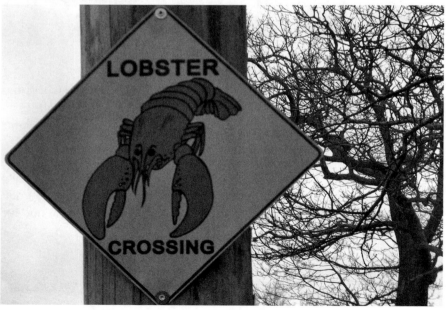

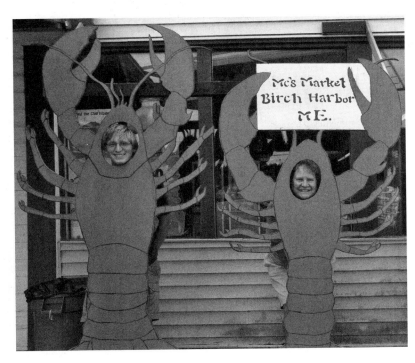

A History of Culture, Conservation and Commerce

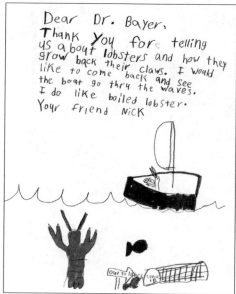

Above: Close-up of Pieter de Ring's *Still Life with a Golden Goblet*, painted in the early to mid-1600s.

Left: A thank-you note from a primary school student following a visit by Dr. Bayer.

traps. The catch, however, is the catch. Under a demonstration license, any lobsters hauled up in the traps must be returned immediately to the sea (after a few photos for bragging rights, of course). Lobstermen have a wealth of knowledge about lobsters and fishing but also about their harbors and other marine life. Views from the water looking in can be as spectacular as those from the land looking out to the ocean. Lobster fishing can be the experience of a lifetime for visitors to Maine.

Everything from Trinkets to Treasure

Lobster art has taken many forms over the years. This unlikely beauty has graced paintings by world-renowned artists, as depicted in a Pieter de Ring painting titled *Still Life with Golden Goblet*, in which a magnificent lobster is draped on a blue velvet–clad table. On the flip side, the lobster has also been the subject of many a drawing by schoolchildren, as is evidenced by the photo of a thank-you letter sent to Dr. Bob Bayer following one of his many visits to classrooms across Maine to talk about lobsters.

The lobster has inspired folk art and crafts. This artwork can be found in every gift shop up and down the coastline. These shops are also filled with a multitude of lobster trinkets or swag such as key chains, ball caps and coffee mugs. What tourist hasn't left the state of Maine sporting a T-shirt or sweatshirt emblazoned with a lobster in some shape or form, be it the traditional red or an impressionistic swirl of many colors? From lobster cutouts to lobster carvings of various sizes, lobster sculptures made of brass and beautiful etchings in glass, there is something for everyone—whether in the stores or along the roadside. It is a significant part of the lobster culture and the lobster economy.

It is not only the tourists who enjoy lobster art and culture; the lobster is a point of pride for many Mainers as well. And it's not just in summertime that the lobster is proudly on display. One can find it all year long on official Maine specialty license plates. (An added bonus is that part of the proceeds from the registration fees for these plates is channeled to lobster research.) *Homarus americanus* can even be found on unofficial road signs. Motorists are apt to find cautionary "Lobster Crossing" warnings on telephone poles and signposts during their travels through lobstering villages. In the village

A History of Culture, Conservation and Commerce

The Lobster & Fish House at Cape Porpoise.

A giant lobster climbs aboard a boat outside of Ruth & Whimpy's Restaurant in Hancock. *Courtesy of Michelle A. Libby.*

Alley's Traditional Maine Lobster Bake

Reprinted from *A Lobster in Every Pot: Recipes and Lore*, with permission from the Lobster Institute.

- *Build a fireplace by piling up cinder blocks 2 rows high to form the base. Place an iron [sheet of metal] on top to make a table. Sometimes we flatten an old fuel tank for the iron. The size depends on the number of people. For 30 to 100 people, you need an iron that is approximately 4' x 6'.*
- *Place a layer of seaweed, at least 6 inches thick, on top of the iron.*
- *Put eggs in cardboard (not Styrofoam) cartons with holes poked in the bottom and place them on top of the seaweed in the center.*
- *Place potatoes (that have been cleaned and wrapped in foil) and onions (peeled and wrapped in foil) on top of the eggs.*
- *Place corn (partially husked and some silk removed) on top of potatoes, onions and eggs.*
- *Using untarred roofing paper, cover the back of the bake and hold in place with rocks or bricks. Have someone hold the paper up in the front while lobsters and clams are added.*
- *Mound the lobsters on top of the corn. Then, mound the clams on top of the lobsters. The juice from the clams and lobsters cooks the potatoes, onions and corn.*
- *Lower the paper attached at the back over the clams. Add another sheet of paper to cover the front and one more length of paper to cover the seams.*
- *Cover the whole bake with at least 6 inches of fresh seaweed.*
- *Light the fire and cook 45 to 60 minutes. A good way to tell if everything is done is when the juice stops running off the iron.*
- *When "picking the bake," watch out because everything will be very hot.*

(Recipe handed down from Ambrose to Ernest to Lewis Alley, South Bristol)

While Rockland's Maine Lobster Festival is the biggest and most widely recognized, numerous other lobster feasts and fairs are held in Maine's coastal communities throughout the tourist season. Lobster boat races, foot races across a line of floating lobster crates and, of course, shucking and eating contests provide plenty of entertainment at such festivals. Heaps of steamed lobster, corn on the cob, clams and blueberry pie are served up every summer at picnic tables, on beaches and in open fields and community halls. A lobster bake (sometimes called a clambake) on the beach is an experience that has been enjoyed by both visitors and locals since the early 1900s. It's not just the lobster that provides the allure of this Maine tradition. There is also joy in the entire ritual of digging the pit in the sand or building a fireplace with cinder blocks; lining it with hot rocks, coals and embers; layering wet seaweed between piles of corn, potatoes and other select items; and topping off the mound with lobsters and clams for steaming.

The ubiquitous lobster shacks that pepper the shoreline of every cove and harbor—and even extend inland to almost as many places as there are towns in southern and eastern Maine—are a cultural marvel in and of themselves. Some are only take-out restaurants, while others offer table service, usually both inside and outside. No matter what the size or style, a true lobster shack will be covered with lobster-related "stuff" and lobster art. Buoys, traps, bait bags, miniature or even full-sized lobster boats—every type of lobstering paraphernalia known to man can be found hanging from the walls and in every nook and cranny of an authentic lobster shack. Many have an outdoor fireplace or cooker for steaming. These shacks not only serve up delicious lobster rolls, stews and sumptuous whole boiled or steamed lobsters, but they are also tourist attractions and provide photo opportunities in their own right.

In addition to eating lobsters, many visitors to Maine want the full experience of going out in a lobster boat and hauling traps themselves. As part of Maine's creative economy, several lobstermen have started giving lobster boat tours as a way to earn some extra income. A very few have turned to the tour boat business full time and obtained larger boats and special licenses to carry greater numbers of passengers. However, the majority of working lobstermen who choose to give tours on the side have adapted their own boats to take up to six passengers per tour. If a lobsterman wants to keep the catch he or she lands on these tours, no special license is needed, but the passengers are not allowed to handle the gear or haul the traps. However, if a lobstermen obtains a demonstration license, the passengers can participate in the lobster fishing—everything from stuffing the bait bags to hauling the

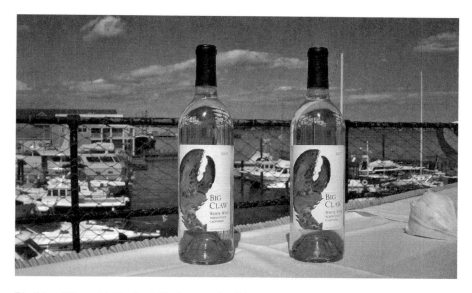

Big Claw Wine with Portland Harbor as a backdrop.

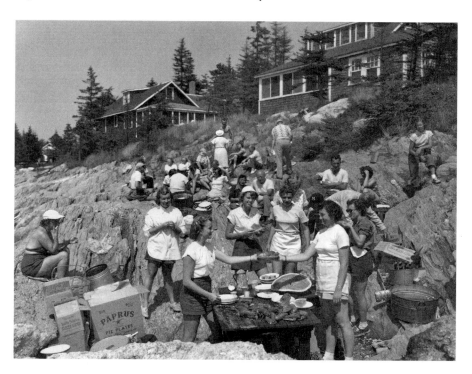

A lobster bake on the rocks at Sebasco. *Courtesy of Maine State Archives (via the Lobster Institute).*

area, and heritage trails (such as the Downeast Fisheries Trail) highlight points of interest related to the lobster industry. Lobster culture and cuisine have a special niche within the lobster industry. The quest for lobster and the lobster experience lures thousands of visitors to travel up and down Maine's 3,478 miles of coast. Witness the Maine Lobster Festival, which has been held in Rockland every year since 1947. It now helps bring in nearly $1 million of "outside" money into the regional economy and was recognized by Events Business News as one of the "Top 250 Events in the United States."[33]

The emblem of the coast of Maine and symbolic of some of the very best Maine has to offer, this benthic and likely prehistoric creature—the lobster—has become a cultural icon for the state. When you ask someone outside the state (or "from away," as Mainers would say) what he or she thinks of when someone says "Maine," it's a good bet that nine times out of ten that person will say, "Lobster!"—with the exclamation point nearly audible. They might even try to imitate the equally iconic Downeast accent and say, "Lobstah." Books have been written about the unique speech and turns of phrase from this heart of lobstering country. Many a famous actor has done his best—with varying degrees of success—in mimicking the intonations of a Downeaster. An "r" becomes "ah" or "aw," as in, "I brought some wicked good lobstahs home and dropped 'em on the pawch befoah I pahked the cah in the bahn." Words ending in "ing" will be pronounced without the "g," as in, "I'm goin' fishin' today." And in a bizarre twist, words ending in "a" are often pronounced as though they end in "r," as in, "Let's get goin' to the stoah so I can get a soder."

No matter how you say it, lobster and lobstering communities are big reasons why tourists come to Maine (with no offense to Maine's fabulous skiing at its western mountains, or amazing wild blueberries, or the official state snack: the whoopie pie). A visitor to the state can easily center all his or her culinary experiences on Maine's premier seafood. Lobster omelets and lobster eggs Benedict can be found for breakfast. Of course, the lobster roll makes the perfect lunch, and a new favorite might be a lobster grilled cheese sandwich. For snacks, one might try lobster ice cream—yes, chunks of lobster in creamy vanilla. The traditional steamed lobster, "lazy man's lobster" (already pre-shelled) or a special lobster creation of the day from the chef can be found on the dinner menu of nearly every fine restaurant near the coast. A savory lobster cheesecake or the classic lobster stew make perfect appetizers. There is even a specialty wine, Big Claw, and locally crafted beers that have been created specifically to pair with lobster.

CHAPTER 11

A CULTURAL ICON, A COMMUNITY HERITAGE

EXPERIENTIAL TOURISM

Maine's invaluable marine habitat and its fisheries are intricately woven into the fabric of the economic, social and cultural well-being of its coastal communities. As the Pew Ocean Commission's report "America's Living Oceans" states, "Though a price tag has never been assigned to our coastal economy, it is clear that it contributes significantly to our nation's overall economic activity. Tens of thousands of jobs in fishing, recreation, and tourism depend on healthy, functioning coastal ecosystems."[31] Tourism in Maine is indeed a significant economic driver. A recent report compiled for the Maine Office of Tourism notes that tourism generates $13.4 billion in the sales of goods and services, 173,181 jobs and $549 million in tax revenues in Maine. This report also indicated that a visitor survey revealed that the most popular experiences on Maine trips were visiting small towns or villages (64 percent), visiting beaches/ocean (59 percent) and eating a lobster (43 percent). Furthermore, Maine's coastal regions accounted for approximately 70 percent of the most frequently visited regions in Maine.[32]

Cultural tourism and experiential tourism—travel directed toward experiencing the arts, heritage and special character of place—plays a large role in Maine's tourism industry, and this is especially true for Maine's lobstering communities. Maine's several maritime museums and local historical societies prominently feature the lobstering history of the

spring of 2011, along with the subsequent dip in the boat price to close to just one dollar, sounded the final alarm in the call to bolster marketing efforts. The Lobster Advisory Council organized an endeavor to create a revitalized marketing entity with an increase in the amount of funding. It held a series of public forums around the state to gather input from lobstermen and dealers about their willingness to back such a new marketing arm for their industry. With mounting support from a majority of constituents, the Lobster Advisory Council worked with the commissioner of DMR and willing legislators to put forward a bill to dissolve the MLPC and establish the Maine Lobster Marketing Collaborative. LD 486, "An Act to Provide for the Effective Marketing and Promotion of Maine Lobster," was passed by Maine's legislature and signed into law by Governor LePage in July 2013. A schedule of increases in license surcharges are to be implemented to fund the new collaborative. By 2016, the budget for the new collaborative will be between $2.25 million and $2.50 million. Of this total, DMR commissioner Patrick Keliher notes, "That's a far cry above the $350,000 allotted to the MLPC and is in line with the marketing budget for other natural resources. It starts out at $750,000 for the first year, $1.50 million in the second year and $2.25 million for years three through five. It's [the purpose of the collaborative] straightforward: to increase demand for Maine lobster with the end goal of driving up the boat price. The old Maine Lobster Promotion Council did not have enough money to do that. The collaborative does."

Increasing demand and expanding markets have always been the goals, and the potential is there if a few hurdles can be overcome. Currently, it is estimated that 80 percent of the live lobsters sold in the United States remain within New England and New York. The greater amount of the remaining 20 percent is sold in Nevada (think Las Vegas casinos) and Florida (think cruise ships and displaced New England snowbirds). That leaves thirty-nine of the lower forty-eight states as fair game. China also offers great potential for market expansion. The country's economic growth and the increase in its citizens' discretionary income in the twenty-first century make it a prime opportunity. Lobster remains one of the very few food choices that still must be purchased and kept alive until immediate cooking to be enjoyed in its fresh, unprocessed state. The perennial challenge of shipping live products any great distance remains a hurdle, especially for Asian markets. Future technological advancements could make this a moot point someday, but for now the challenge remains. This likely means that the increased availability of processed lobster in its many forms will provide the greatest opportunity for market expansion.

The Maine Lobster logo was created by the Maine Lobster Promotion Council to help brand Maine lobster.

turn Maine lobster into "Product of Canada" or "Boston Lobster" once it was shipped to processors and distributors outside Maine's borders—caused a push to truly brand the Maine lobster. The MLPC created the Maine Lobster logo, which was used on everything from claw tags to restaurant menus and shipping boxes.

The charge to the MLPC to promote "the unique character of the coastal Maine lobster fishery" took on a new urgency. The pristine waters of Maine were being touted, the term "wild caught" was being hyped and idyllic harbors with traps and boats became backdrops for ads and websites. Lobstermen were engaged more often to advertise their catch, as was seen in the campaign where Clive Farrin, a lobsterman from Boothbay Harbor, was exhorting folks to "get crackin'."

Many lobstermen and lobstering communities also took on the task of marketing their own lobsters. Lobstermen began using claw bands sporting the name of the harbor in which a lobster was caught. Some even went high-tech, putting a web address on their lobster bands that would connect consumers with a site linking them with the actual fisherman who landed their lobster. Some fishermen and co-ops began their own online stores and started shipping lobsters across the country, often including a photo and personal note. A couple enterprising lobstermen even started advertising the opportunity to purchase the entire catch from one of their lobster traps for the season, along with digital video of trips out on the boat when "their" trap was hauled.

The movement to promote Maine lobster took a giant step forward in 2012. Yet again, the charge toward progress was initiated by the lobstermen themselves. The overabundance of soft-shell lobsters landed in the early

> *investments made by lobster license holders and undertake those media or promotional efforts that represent the most cost-effective use of a limited promotional budget. The Council shall remain responsive to the Maine lobster industry, conduct its business in a public manner and undertake marketing efforts that promote the quality and full utilization of the product and the unique character of the coastal Maine lobster fishery.*

The council's budget was, indeed, limited. It was funded by a surcharge placed on the state licenses of all lobster harvesters, dealers and processors—but only to the tune of about $350,000. Marketing Maine's king of crustaceans to state, regional, national and international markets, as the statute called for, with such a small budget was a tall order.

The Maine Lobster Promotion Council (MLPC) did its best. It participated in overseas trade missions and attended international seafood shows in places as far away as Brussels and as close as Boston. It also developed the marketing catchphrase "Lobster—the Ultimate White Meat" in 1993. Use of this phrase was later contested in 1997 by the National Pork Producers Council, which had been using the phrase "the other white meat" to market the healthy qualities of pork versus chicken. While not agreeing with the contention that "the ultimate white meat" infringed on any trademark rights, the MLPC eventually dropped the phrase from its marketing materials under threat of a $75,000 lawsuit. The whole incident did manage to keep both pork and lobster in the news, at least for a few weeks.

In addition to touting lobster to seafood buyers and consumers, the MLPC worked to educate chefs. It instituted the Maine Lobster Chef of the Year competition, which was held in such high esteem that it was staged at the Governor's Mansion until it finally outgrew that location and became a highlight at Portland's Harvest on the Harbor festival.

Many product brand names have become used commonly as nouns in our everyday lexicon—Kleenex, ChapStick, Crock-Pot and Post-its to list a few. Recently, some in the industry felt this was becoming the case with Maine lobster, as it had become nearly synonymous with all American lobster, no matter where it was caught. Certain restaurants were even using the word "lobster" on their menus to describe certain seafood that was not even any species of lobster. Most notable was the langostino, which was dubbed "imposter lobster" by the MLPC. This, together with three other factors—the consumer movement to buy local (or at least from U.S. companies), the traceability trend (wanting to know where one's food is coming from) and the product of origin labeling regulations that seemed to

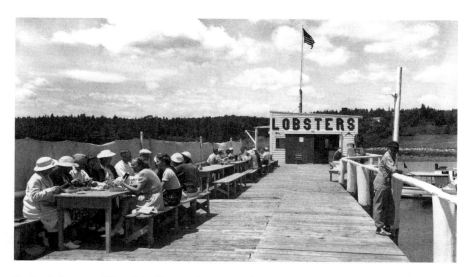

Eating lobster at Gibert's in Pemaquid, 1938. *Courtesy of Maine State Archives (via the Lobster Institute).*

This laissez-faire approach to marketing took a turn in the 1990s as the lobster catch ballooned. Records of Maine's commercial lobster catch go as far back as 1880, when 14,535,102 pounds of lobster landings were reported by what is now the Department of Marine Resources (and it is quite possible that "reported" could be the key word here). It wasn't until 1991 that the lobster landings exceeded 30,000,000 pounds, but that had more than doubled by 2002, when 63,625,745 pounds were recorded. As we've seen, over 126,700,000 pounds of lobster were landed in 2012. The catch in 1880 was valued at $300,000, while today's catch is valued at over $340,000,000. Granted, methods of reporting have been refined and more strictly enforced over the years, but the increase is still more than substantial.

Again, in a fortuitous show of foresight, the lobster industry took action in 1991 by pushing for the creation of a marketing entity focused strictly on lobsters. In that year, the Maine legislature enacted a statute (#12004) that created the Maine Lobster Promotion Council. The wording of the original statute states that the Maine Lobster Promotion Council was

> *created to promote and market actively Maine lobsters in state, regional, national and international markets. The council shall draw upon the expertise of the Maine lobster industry and established private marketing firms to identify market areas that will provide the greatest return on the*

CHAPTER 10

Marketing:
A Taste of Maine

Luxurious, succulent, sweet, tender, mouthwatering, natural, delicious—these adjectives and more have been used to describe lobster. In the early years of the lobster industry, and even right up to the end of the twentieth century, lobsters seemed to sell themselves. Granted, as with any commercial product, there were ups and downs in supply and demand. Simple word-of-mouth advertising first started a craze for lobsters in Boston and New York starting in the 1880s. During World War II, lobster was considered a delicacy and as such was not rationed. Businessmen and their families who amassed a fair amount of wealth in the booming wartime economy were demanding more lobster than ever before. Lobster landings had experienced a bit of a lull in Maine in the early 1900s, but as luck would have it, they picked up during and just before the war years. But was it really luck? Two lobstermen—Ed Blackmore of Stonington and Alison Bishop of Corea—who were interviewed independently of each other during the Lobster Institute's Oral History Project both recounted the same tale. They said the increase in landings at this time was due to bombing tests along the coast of Maine, particularly near Seal Island, which stirred up the lobsters and helped increase the catch.

Up until 1988, the lobster landings in Maine never reached more than 20 million pounds. Finding markets for the live product available was not a great challenge, especially when airfreight opened the European market for American lobster in the late 1950s and 1960s. From lobster shacks to five-star restaurants, the entire lobster catch seemed to flow readily from boat to plate, be they made of paper or the finest china.

purpose, in addition to finding a use for the shell waste, was to introduce an environmentally friendly golf ball to cruise ships, Audubon-certified eco-friendly golf courses, the U.S. Navy and Merchant Marines, oil rigs, etc.—basically any location where single-use, practice golf balls might be driven into the water. In 1991, the signing of the international MARPOL V Treaty banned the practice of hitting golf balls into the sea. If commercialized, this new biodegradable lobster golf ball could reinstate this practice.

The university provides the perfect incubator for Maine's future lobster scientist. Students at all levels and from a diversity of disciplines are brought into experiments related to lobsters and the lobster fishery. They work side by side with lobstermen as well as faculty. Education and training reaches down into the high schools and elementary schools as well, bringing the science of lobsters to all ages.

Today, lobstermen are more actively involved than ever in research that is vital to their fishery, and they would not have it any other way. They serve as data collectors, bait testers, health monitors, stock assessors and in many other roles. They work together with researchers, both on the boat and in the labs. They have earned a seat at the table when it is time to set research priorities, and they have gained respect, as Ed Blackmore coined the phrase, as "scientists in their own right."

A juvenile lobster found its way into a sampling trap. *Courtesy of Bob Bayer.*

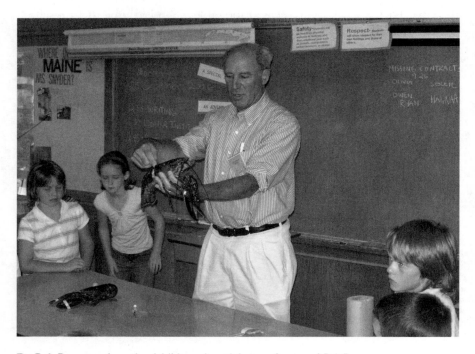

Dr. Bob Bayer teaches schoolchildren about lobsters. *Courtesy of Bob Bayer.*

Left: A biodegradable golf ball made using recycled lobster shells was developed at the University of Maine. *Courtesy of Bob Bayer.*

Below: Sampling traps for use in stock assessment are designed to catch juvenile lobsters. Joe Chalmers (left), a lobsterman from Southwest Harbor, works with University of Maine student Bill Fike (right). *Courtesy of Bob Bayer.*

A History of Culture, Conservation and Commerce

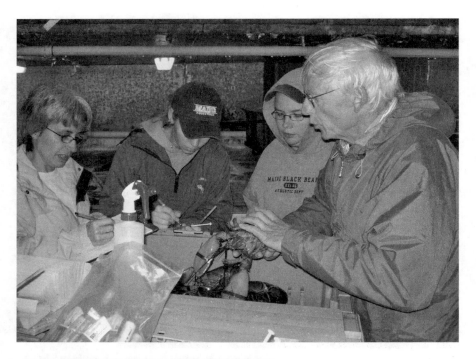

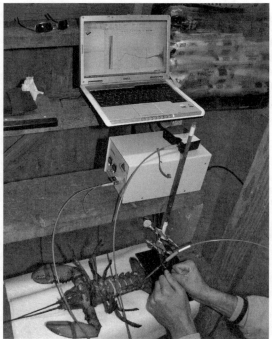

Above: Health monitoring project of the Lobster Health Coalition being conducted at the University of Maine Aquatic Animal Health Lab.

Left: Dr. Jason Bolton, then a doctoral student at the University of Maine, uses a sensor to measure serum protein in a lobster. *Courtesy of Bob Bayer.*

called after the extensive die-off of lobsters in Long Island Sound in 1999, and in 2008, it spurred the formation of a Lobster Health Coalition (led by Anne Lichtenwalner and Deborah Bouchard), composed of regional lobster scientists. The Health Coalition was the first modern-day entity (and perhaps the first ever) to gather baseline data for lobster health monitoring.

The university's research has also focused on such topics as producing better models for stock assessment (Yong Chen), predictive tools for lobster population trends (Richard Wahle), the social and economic anthropology of lobstering communities (James Acheson), lobster ecology and habitat (Robert Steneck), marine policy and economics (James Wilson), food product development (Bob Bayer, Denise Skonberg and Al Bushway), the use of sensors to measure lobster vitality (Jason Bolton), the use of processing byproducts for non-food purposes (Bob Bayer); assessing the effects of environmental toxins on lobster health (Bob Bayer, Rodney Bushway and Lawrence LeBlanc) and many more.

One of the more unique and highly publicized value-added products developed at the University of Maine (by Drs. Bob Bayer and David Neivandt) from discarded lobster shell was a biodegradable golf ball. The

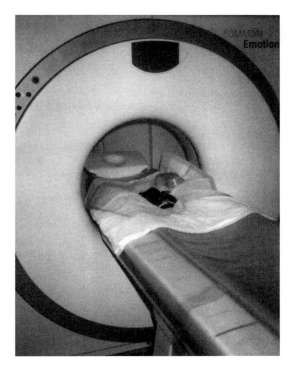

Lobsters with shell disease being scanned using MRI technology.

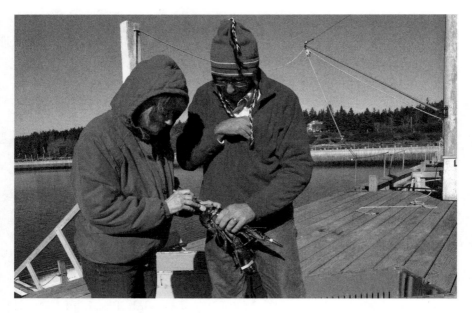

Kathy Heanssler (left) of Conary Cove Lobster Company works with Dr. Bob Bayer (right) of the Lobster Institute to draw blood for a research project.

and celebrated the role of lobstermen as scientists. Now it is not unusual for lobstermen's associations to have a scientific committee as part of their organizational structure. Other groups linking scientists with fishermen have also been formed. In Canada, the Fishermen and Scientists Research Society was started in 1993. The Northeast Consortium was established in 1999 "to encourage and fund effective, equal partnerships among commercial fishermen, scientists, and other stakeholders to engage in collaborative research and monitoring projects in the Gulf of Maine and Georges Bank."[30] It is based at the University of New Hampshire and is composed of four research institutions: the University of New Hampshire, the University of Maine, the Massachusetts Institute of Technology and the Woods Hole Oceanographic Institution. However, the Lobster Institute remains the only region-wide organization that focuses solely on the American lobster.

University of Maine researchers have often taken the lead in research related to lobster health and biology. In 1987, Dr. Bob Bayer and his team were the first to develop a vaccine, delivered via medicated feed, to cure gaffkemia (also known as red tail). Researchers affiliated with the university's Lobster Institute began conducting studies on shell disease in 1988 and continue to this day. The Lobster Institute was one of the first

We at the University of Maine are proud to be a part of this new research and education effort.

The institute would be headed by an executive director appointed by the University of Maine in consultation with a board of advisors composed of industry representatives from all sectors. The board of advisors would provide counsel to the executive director in identifying and establishing research and programming priorities and on administrative matters relating to the institute. They board of advisors was also to actively provide assistance to institute scientists, educators and students in carrying out their research. It was to be a hands-on involvement that would grow rapidly.

Dr. David Dow from Maine Sea Grant was named the first executive director of the Maine Lobster Institute, and Ed Blackmore was elected as the first chairman of the board of advisors. Blackmore noted, "The idea behind the institute is to get more people involved in lobster problem solving and to keep them talking to one another. We all need each other, and lord knows there's plenty for all of us to do. Every lobsterman is a scientist in his own right. Because what does a scientist do? He takes information, looks at it and uses it to make a living."

Almost from its inception, the founders looked to expand the institute's reach. They realized that a unified approach (geographically and between sectors) would be most effective in dealing with the challenges faced by the lobster industry. In the fall of 1987, the Massachusetts Lobstermen's Association became actively involved in the early stages of the institute's development. Due to its increasing regional focus, in 1989, the word "Maine" was dropped from its title, and the organization was renamed the Lobster Institute. Today's Lobster Institute boasts a board of advisors with representatives from major lobster industry associations and businesses, as well as researchers and community members ranging from New York through the Canadian Maritime Provinces. Dr. Bob Bayer is the current executive director, having replaced David Dow in 1995. It was at this time that the Lobster Institute shifted its direct affiliation with Maine Sea Grant to the University of Maine's Agricultural and Forest Experiment Station. Ed Blackmore retired after ten years of service as chairman of the Lobster Institute's board of advisors. William Adler, executive director of the Massachusetts Lobstermen's Association, assumed the chairmanship in 1997, a post he still holds today.

The foresight of the five original stakeholders germinated a new approach to lobster science (and fisheries science in general)—one that recognized

scientific communities. Even though there had to be public hearings before any changes in regulations could be made law, lobstermen still felt that their voices were not truly being heard.

Characteristically, Maine's lobstermen eventually decided to take the initiative to rectify this situation. They worked with other industry sectors to form a plan. In 1985, a delegation led by Ed Blackmore, then president of the Maine Lobstermen's Association; Bob Brown, president of the Maine Import/Export Dealers' Association; Herb Hodgkins, president of the Maine Lobster Pound Owners' Association; and Joe Vachon of the MLA contacted officials at the University of Maine's Sea Grant program to open discussions on finding ways to work together. What evolved from these conversations was the formation of the Maine Lobster Institute. The plan was to create an independent body—linking those in the lobster industry with scientists at the University of Maine—that would identify lobster industry challenges and focus research and educational efforts to solve them. University of Maine president Dale Lick approved the concept in 1986, and formation of the Maine Lobster Institute was authorized by the University of Maine Board of Trustees on July 20, 1987. Its initial charge was to "conduct research and provide information to protect, conserve, and enhance the Maine lobster resource and its environment in order to ensure the continuance of a viable lobster industry that will benefit Maine people." President Lick announced the formation of the Lobster Institute with the following words:

> *The Maine Lobster is the unrivaled symbol of the Maine coast, a creature surrounded by the respected traditions of hardworking, independent people who serve as a vital link to our maritime heritage.*
>
> *These words also have another important meaning because they represent the most valuable marine species in Maine's economy. The 1986 catch returned nearly $46 million to Maine lobstermen alone. This figure equals almost half of the landed value of Maine's commercial fish catch. The lobster industry is one of the state's and the regions' largest employers.*
>
> *Because of its unique cultural value and significant economic importance, the Maine lobster—its conservation and enhancement—is of special interest to a wide variety of people in Maine, New England, and the Maritimes. Recently these people formed an association to more clearly focus the efforts of all those who share a common concern about the future of the lobster industry.*
>
> *It is my pleasure to introduce you to the Maine Lobster Institute, a cooperative program with the lobster industry and the University of Maine.*

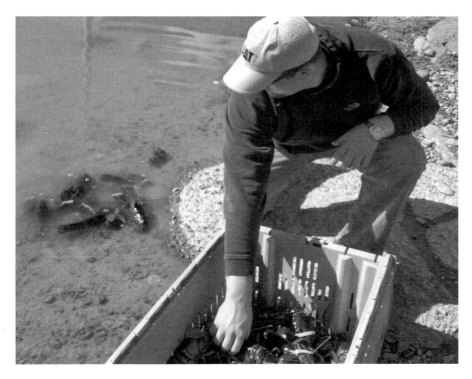

Tagging juvenile lobsters for release and future reporting upon re-catch as part of a scientific study by the Lobster Institute. *Courtesy of Bob Bayer.*

marine patrol sections, each having 7 or 8 patrol officers. Among the staff is a full-time lobster and crab biologist who, among many other duties, helps coordinate stock assessment efforts. DMR uses its own data from ventless trap studies, sea samplings and trawl surveys and participates with federal scientists and scientists from other states to reevaluate the lobster stocks on a regular basis.

In the early years of the management process, and up until fairly recently, there was often a serious distrust or, as Dunbar noted, "antagonism" on the part of lobstermen toward science. Lobstermen were typically excluded from playing any role in the scientific realm, and they often felt that what the scientists were concluding did not jive with what they were seeing and experiencing every day out on the water. This was particularly true when it came to assessing the populations of the stock. Rightfully so, the lobstermen felt they had a breadth and depth of knowledge that was being disregarded and, in some cases, disrespected in the management and

three commissioners, with one being assigned general supervisory duties. The first such commissioner was E.W. Counce of Thomaston. The position of director of Sea and Shore Fisheries was established in 1917 and first filled on January 3, 1918, with the hiring of Oscar H. Dunbar of Jonesport, at a salary of $2,000. He held the position for only about three months before being replaced by Harry L. Sanborn of Vinalhaven in April. The commission transmitted its first biennial report to then-governor James P. Baxter in 1918:

> *The conditions confronting the Commission in this important department were found to be chaotic, with a widespread feeling of antagonism on the part of the dealers and fishermen. To overcome this, it has been and is the desire of the Commission and it has regarded it as a duty to keep in close personal touch with those connected with the fishing industry, giving prompt attention to any request, with the best service within its power.*
>
> *That this department is in its infancy is best shown by the manifold duties to be performed today, in comparison with those a few years since. The alteration in the methods of business, administration, and rapid means of transportation with the immense demand for fish food requires constant attention.*
>
> *By the act of legislature creating the Commission of Sea and Shore, authority is given them to "make rules and regulations governing the time, manner and conditions of taking fish, shell fish and lobsters, and to declare a close time on such varieties and in such localities as they may determine; but such rules and regulations shall be made, and such close time declared only after a hearing, reasonable notice of which shall be given in publication, or otherwise to all parties interested."*

The Department of Sea and Shore Fisheries evolved into the present-day management entity known as the Department of Marine Resources (DMR). The role of the DMR has greatly expanded over the decades since the first management regulations were put in place. By statute (Maine Title 12, Chapter 603 §6021), DMR is still responsible "to implement, administer, and enforce the laws and regulations" established to conserve marine resources. However, the department is now also charged to "develop marine and estuarine resources; to conduct and sponsor scientific research; [and] to promote and develop the Maine coastal fishing industries."[29] Personnel has grown from the meager 2 commissioners first appointed by Governor Chamberlain to a full staff of nearly 120 plus 6

CHAPTER 9

THE SCIENCE OF LOBSTERS: RESEARCHERS AND REGULATORS

An often overlooked part of the lobster industry (at least to the outside observer) is the lobster science and management sector, which builds its work around researching and regulating the resource. This is a layer within the lobster industry that wraps itself around all segments and impacts everything from day-to-day fishing to trends for the future. Research on lobster health and ecology is extremely important in order to safeguard the well-being of this singular natural resource on which so many base their livelihoods. That being said, research surrounding the industry does not solely focus on the lobster itself. Ways to improve lobster gear, shipping practices and value-added food product development, as well as finding a way to use processing waste, are just some of the topics being tackled by industry and academic scientists.

Given that regulations placed on lobster fishing must be dictated by the "best available science," it is easy to see why lobstermen would want to be reassured that scientists get it right when it comes to estimates of size at maturity and all of the other biological factors that influence management decisions. These decisions have had and will continue to have an impact on the way they are allowed to fish and, ultimately, their very livelihoods. Maine's first regulator body governing the lobster fishery was the Department of Sea and Shore Fisheries, established in 1867. Legislation called for two commissioners, and Nathan W. Foster of East Machias and Charles G. Atkins of Orland were the first appointees, tapped by then-governor Joshua Chamberlain. In 1885, the law was amended to allow for

a five-year process of pre-assessments, industry responses and the final full assessment, Maine's lobster fishery received official MSC certification as a sustainable fishery. The total price tag reached over $300,000—not including the cost for future use of the eco-label. The achievement was announced by Governor LePage at the 2013 International Boston Seafood Show. Governor LePage proclaimed, "The Marine Stewardship Council's certification will provide the Maine lobster industry with a globally recognized seal of approval. This certification recognizes our longstanding practices of good stewardship and ensures that every lobster caught in Maine waters can be marketed not only as delicious, healthy food, but also as a resource that meets the most stringent international environmental standard for seafood sustainability."

The goal of becoming more "green" or environmentally friendly was appearing more frequently in the strategic plans of many corporations. It was not only responsible but also a great marketing tool. Several key players in the wholesale market, including powerhouse Wal-Mart, began demanding that all the fish they purchased be certified as sustainable, MSC or otherwise.

Lobster distributors and processors were not immune to this movement. Starting in 2005–06, some of them began seeking buy-in from Maine lobstermen to apply for MSC certification of the state's lobster fishery. They were concerned about maintaining existing European markets and hopeful that the sustainability certification would open new markets. Heated debate swirled around this issue for several years within the lobster industry. Believing that the lobster fishery's historic commitment to conservation and its well-established management structure and extensive regulations spoke for themselves, many lobstermen felt that the sustainability of the lobster fishery was already clearly evident. They did not appreciate the fact that outsiders from London wanted them to pay to authenticate what they already knew to be true. They realized that sustainability had become a buzzword in lobster advertising and promotions, yet some lobstermen felt that if they just told their own stories, no outside eco-labeling was necessary.

But the call for sustainability certification in the marketplace did not go away. In 2008, a coalition of lobster wholesalers formed a private group known as the Maine Fund for Sustainability, which began actively raising the funds and the support of lobstermen needed to go through the MSC certification process. Notable members of the group included Linda Bean, a Port Clyde lobster dealer, and John Hathaway, a Richmond processor. In an interview with Mike Crowe of local Maine newspaper *Fishermen's Voice*, John Hathaway was quoted as saying, "Some processors want certification for marketing purposes. They want it to be able to retain a position in changing markets that want sustainably harvested seafood. Setting Maine lobster apart, through certification, could open new markets. Consumers want sustainable seafood. We could lose markets without certification."[28]

The continued discussions surrounding this issue, combined with the overall economic downturn of the times and declining boat prices, spurred Maine's governor, Paul LePage, to establish a task force to make recommendations on ways to help maintain the economic viability of the lobster fishery. The Maine Lobstermen's Association stopped short of an endorsement but did say that MSC certification was worth considering. With views still mixed within the industry, the Maine Fund for Sustainability put up $150,000 in December 2008 to begin the MSC external audit. After

method involved letting a female lobster hatch its eggs inside a cylindrical fine-mesh wire container floating in a harbor. Again, the concept was that the larval lobster would remain protected in the cylinder, dubbed "the Nest," while in its natural environment and feeding on its natural diet. To date, neither of these techniques has worked, as the mesh in both cases was not fine enough to contain the miniscule larvae. It is possible that refinements could increase their effectiveness.

Another rather simple conservation instrument that was first employed in 2010 is the Habitat Mooring System, invented by Stewart Hardison. This is a multipurpose unit that serves as either a boat or buoy mooring and provides a place for lobsters and other marine life to take shelter. It is a flat-topped, pyramid-shaped concrete block that has tunnels and channels of various sizes running through it. These chambers create the secure habitat that many lobsters are constantly seeking. Dives have shown that, at one time or another, lobsters have taken up residence in each of the different-sized habitat chambers.

Certified as Sustainable

As the global fishing industry moved into the twenty-first century, it experienced an ever-increasing call for sustainable fishing practices. Environmentalists all over the world placed increasing pressure on fisheries and those who purchased fish at the wholesale level to implement best-management practices to ensure that no species would be overfished. Non-governmental organizations (NGOs) began specializing in what became known as third-party certification of sustainable fisheries. Most notable among these was the Marine Stewardship Council (MSC) based in London, England, which began operations in 1999. Working with scientists, the MSC developed a set of criteria for sustainable fishery management and operational procedures. Once a fishery applied and paid for the chance to become MSC certified, it was put through a rigorous series of inspections. If the fishery passed these inspections, it was granted certification and the opportunity to purchase and use the MSC's eco-label on its products. European markets were the first to embrace eco-labeling and third-party certification. While other options were available, MSC quickly became the industry standard.

to the ocean floor and find shelter once released. This, it was assumed, would greatly increase their chances for survival and begin to grow or regrow the lobster population in areas where they were seeded. The Downeast Institute for Applied Marine Research on Beal's Island, Maine, began and continues to work on both land- and sea-based rearing facilities. The land-based Zone C Lobster Hatchery was started in Stonington, Maine, in 2006 by the Penobscot East Resource Center. It lasted for five years before running out of funds. It successfully released approximately 100,000 Stage IV juvenile lobsters during that time and added a wealth of knowledge on methods to evaluate survival rates. This included advances in using genetic identification of lobsters so that they could then be linked back to the hatchery after release and recapture.

Lower-tech methods to enhance lobster stocks were also devised. In Canada, a group known as Homarus Inc. (formed with financial backing and the encouragement of the Maritime Fishermen's Union) began rearing lobsters for release and seeding them in artificial reefs made of stackable concrete blocks that were lowered into the ocean at select locations. While in Maine, a couple very simple methods were tested by the Lobster Institute for seeding lobsters without the rearing phase. One involved attempting to block off a tidal lobster pound with fine-mesh screens and letting egg-bearing lobsters hatch their eggs inside the pounds. The thought was that the larval lobsters would remain protected from predators in the secure pound while still being able to feed and grow in their natural environment. The second

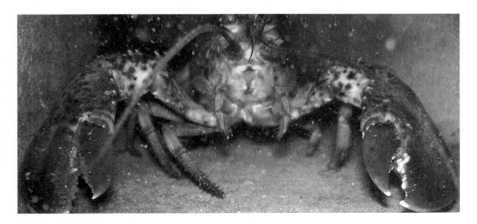

A lobster captured in underwater video in a Habitat Mooring Systems chamber. *Courtesy of Chris Roy.*

sale would be a complex and expensive proposition. Regulations on the minimum size of lobsters that could be sold commercially meant that lobsters would have to be kept in tanks for five to seven years to grow sufficiently to meet the size requirements dictated by law (Maine's being five and one-quarter inches). This meant maintaining proper circulation and water temperature and providing feed for cultured lobsters for that entire length of time. The overhead costs were staggering. Additionally, as the lobsters matured, they would have to be kept in individual holding systems, as they are too aggressive and cannibalistic to share the same tank without some means of segregation.

While some entrepreneurial folks will always come along seeking a profitable way to raise lobsters for sale, the focus on lobster hatcheries at the turn of the century switched to a focus of hatch and release for stock enhancement. This was particularly spurred by the tragic events of 1999 in Long Island Sound. Lobstermen from both Connecticut and New York who fished the sound found dead lobsters in their traps in alarmingly great quantities. In what seemed like the blink of an eye, 99 percent of the fishery in the sound had been decimated. While no smoking gun was ever identified, most scientists would say it was a multitude of factors simultaneously converging on the sound that caused the lobster die-off. There were warming water temperatures that might have raised the lobsters' susceptibility to pathogens, as well as an influx of fresh water into the sound following Hurricane Floyd (on top of an already rainy hurricane season) that had an impact on the oxygen levels in the water. There was also the flushing of deadly pesticides into the sound by runoff from Floyd's torrential rains. These pesticides had been sprayed in many communities along the sound's shoreline in an attempt to control the mosquito population from spreading the West Nile virus. A large quantity of the spraying was done over paved surfaces, which do not absorb and break down the chemicals like vegetative areas do. Hence, the rainwater swept these chemicals into storm drains, and they were then dumped into the sound. Since a lobster is an invertebrate arthropod, just like insects, these pesticides are just as effective at killing crustaceans as they are mosquitoes and other insects.

Whatever the cause or mixture of causes, the effects were devastating, and the death knell was heard throughout all lobstering communities. It revitalized the call to find effective ways to raise lobsters for restocking purposes. The goal became to securely rear larval lobsters to a size called Stage IV—at which time the lobsters would be large enough that they would no longer float in the water column. Rather, they would weigh enough to sink

diet. With juvenile lobsters wandering in and out of traps and grabbing a bite to eat before they go, this added food source could be aiding in increased population growth.

Herring is the primary source of lobster bait in Maine, accounting for 70–90 percent of all types of bait used. According to studies by Jonathan Grabowski from the Gulf of Maine Research Institute, the amount of herring bait used in lobster traps has increased fourfold since 1970. "That's an influx of 100,000 tons of biomass every year, nutrients that lobsters otherwise wouldn't get," says Grabowski.[27]

A lobsterman will, on average, use between 1.5 to 2.0 pounds of bait per trap. Since 1997, the number of tags issued has increased by 13 percent, going from 2.1 million to 3.1 million in fifteen years. Even given the number of traps that go unused, that means a serious amount of bait—or feed, as some might say—is providing sustenance for Maine's lobsters. It can be said that the term "lobster harvester" is truly more accurate than "lobster fisherman."

Hatcheries and Habitat

Scientists, fisheries managers and others involved in the lobster industry have long been searching for effective ways to rear lobsters for either commercial use or to enhance or restock the resource. Europeans, particularly Norwegians, developed lobster hatcheries in the late 1800s. It was Canada that introduced lobster hatcheries to North America in 1891 at Bay View, Nova Scotia. The movement to rear lobsters found its way to Maine in the early 1900s, with the first facility being the Fish Hatchery and Lobster Rearing Station in Boothbay Harbor. These early attempts were both land based and sea based. They met with limited success, and all eventually were discontinued after a few short years. The allure, however, remained. As the value of lobsters increased, hatcheries once again became the focus of aquaculturists and fisheries managers. Maine's Department of Sea and Shore Fisheries (now known as Marine Resources) operated a lobster hatchery in the Schoodic area in the late 1940s. However, it wasn't until the 1970s that a strong interest resurfaced in Maine and other lobstering regions to cultivate lobsters in hatcheries. It became evident that rearing lobsters in land-based aquaculture facilities for later commercial

Is It Fishing, or Is It Farming?

Undoubtedly, the established and well-followed conservation regulations have served the lobster industry well in its efforts to sustain a viable fishery. Equally certain is that they are not solely responsible for the substantial uptick in landings since the 1990s. There are several theories about contributing factors, such as the decrease in the groundfish that were historic predators of lobsters (such as cod and striped bass). Another is the warming trend of coastal waters in the North Atlantic, which might cause larval lobsters to settle more quickly to the bottom to find shelter, thus increasing the chance of survival for a greater percentage of these youngsters.

Perhaps one of the most intriguing speculations, however, is the thought that lobstermen are really more farmers than they are fishermen. As the theory goes, with the great number of baited traps being dropped in Maine's waters, and the inefficiency of those traps in retaining lobsters (particularly the sublegals), perhaps lobsters are getting a free lunch. Some estimates indicate the bait from lobster traps makes up about 50 percent of a lobster's

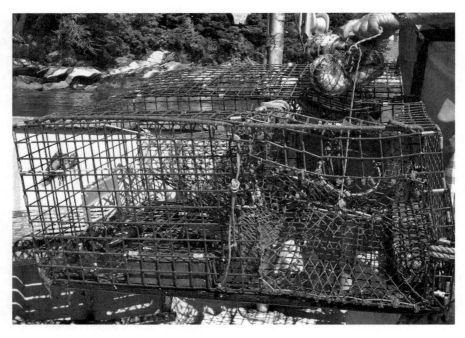

A bait bag stuffed with herring and about to be placed in a trap.

Juvenile lobsters that are somewhat larger yet still sublegal are also able to leave the trap through escape vents that are required to be built into the trap design. These escape vents actually serve a dual conservation purpose. They are also designed to allow larger, legal-sized lobsters to get out of a trap should it ever become detached from its buoy line and thus never hauled. These types of traps are known as ghost traps.

So how does it work? An escape vent is made of a biodegradable plastic material and covers either a square or round hole cut into the side of the trap. The plastic cover has additional holes cut into it that are too small for the legal lobsters to use to escape but are large enough for the juvenile or smaller lobsters. These plastic covers are fastened to the trap using biodegradable hog rings. If caught in a ghost trap, a lobster can simply wait for the fasteners to degrade, at which point the larger escape vent opens up, allowing it to exit. It is easy to see that the method of catching lobsters in traps is full of holes—both literally and figuratively.

Trap limits and limited entry into the fishery are two other means of safeguarding the lobster stocks from being overfished. The trap limit can vary within the seven lobster management zones along Maine's coast. However, eight hundred per lobsterman is the absolute maximum. Each lobsterman is required to purchase trap tags annually. Even if they choose not to fish the maximum number of traps allowed by law, most fishermen will purchase enough trap tags for their entire legal allotment. They view this as a precaution against being squeezed out of any grandfather clause should the trap limits change. This creates a number of what are called latent traps—those marked in the books as being fished but that actually go unused. This does make it difficult to get an accurate measure of what is called "fishing effort," or the number of traps in the water.

Limited entry also varies by zone. Each zone can establish its own system, working together with the Department of Marine Fisheries. One zone might mandate that three licenses must be retired before one new license can be issued. Another might establish a one-for-one ratio. Additionally, to obtain his or her first commercial lobster harvesting license, a lobsterman must enter the Maine Lobster Apprenticeship Program. The program consists of logging a minimum of twenty-four months, one thousand documented hours and at least two hundred fishing days with up to three sponsors who are commercially licensed fishermen. An apprentice lobsterman must also provide documentation of successful completion of a U.S. Coast Guard–approved Fishing Vessel Drill Conductor Course. This apprenticeship helps to ensure that new lobstermen are aware of the regulations and conservation measures required by law.

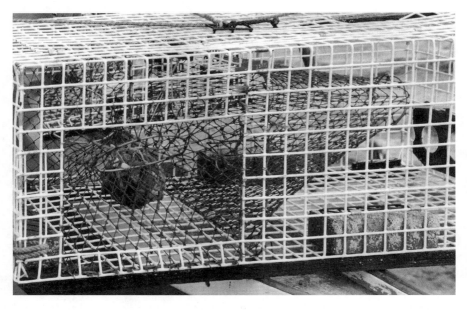

Lobster trap with bait hanging just inside the head and a black escape vent with two holes on the right-hand side.

a trap though an open circular ring known as the head, and from there it finds its way down an ever-narrowing net into the main compartment of the trap, known as the kitchen. There is at least one secondary compartment, known as a parlor, that can be accessed through a similar passageway. There is nothing that prevents this same lobster from turning around and exiting the trap the same way it came in. While perhaps a bit more challenging, underwater video recordings of traps show that it happens more often than one might think. Using such video, researchers from the University of New Hampshire have calculated that only about 10 percent of lobsters that come upon a trap will actually enter, and only 6 percent will actually stay long enough to be hauled up.

There are a few other means of escape for a seemingly trapped lobster, particularly if it is of sublegal size. The size of the wire mesh used to make the traps is regulated by law to be large enough for the very young, small lobsters to go in and out of a trap quite easily. This is particularly useful in keeping them out of harm's way from being trapped with larger lobsters, which might just as readily eat them as they would the bait (yes, lobsters are cannibalistic). Plus, it saves them from the upset of being hauled up, handled and then tossed back into the water since they cannot be legally landed.

Left: Gardner Gross, Stonington, 1984. *Courtesy of Bob Bayer.*

Below: Young fishermen getting ready to haul, 2012.

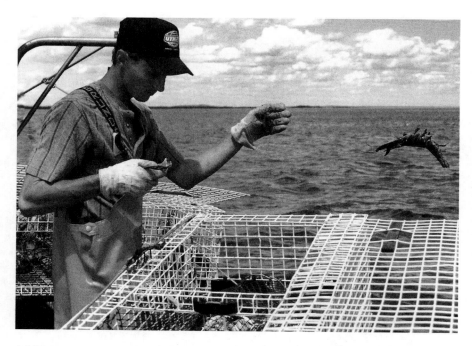

A lobsterman returning a sublegal (undersized) lobster to the ocean. *Courtesy of Bob Bayer.*

of determinations. Therefore, the fishery has seen these measures change over the years, and they might certainly change again with future study.

In addition to the V-notch and size restrictions, there are many seemingly small yet collectively significant conservation methods that have been employed over the years and are now legislated. The methods of fishing, as well as trap designs, are key among them. It is no accident that the iconic images of the lone lobsterman leaving the dock in his boat early in the morning, motoring from buoy to buoy to haul up traps and returning to that same dock before the sun sets have remained basically the same for generations.

According to law, in order to fish in Maine's waters, a lobster boat must be owner operated; that means no factory boats or large fleets of boats owned by corporations. The only legal method of fishing is the trap fishery—no diving and no dragging or trawling with nets. Fishing traps is in no way the most effective way to catch lobsters; however, it may very well be one of the most effective ways to protect the stocks from being overfished.

The very design of a lobster trap is inherently flawed, if you are looking for a foolproof method to catch lobsters. Lured by the bait, a lobster enters

of Marine Resources revealed that number had increased to 80 percent. It wasn't until 2003 that the V-notching of all egg-bearing females before returning them to the ocean became law in Maine, along with a prohibition of future harvesting of these V-notched lobsters.

The enactment of a size restriction on harvested lobsters was a parallel method of conservation that complemented protecting egg-bearing females. The ten-and-a-half-inch minimum size noted in the 1872 legislation evolved over the years as scientists developed a better grasp on the size at maturity of lobsters. They also developed more accurate ways of measuring a lobster. Measuring the size of the overall lobster was found to be inconsistent, and fishery managers switched to using a measure of just the lobster's carapace (or body shell, excluding the tail) to indicate legal size at harvest. After several iterations of the law, the currently legislated legal minimum measure in Maine is three and a quarter inches. Lobsters under this size are referred to as sublegal, and any caught must be returned to the ocean. This places the weight of a minimum-sized legal lobster at about one to one and a quarter pounds.

In addition to the regulation on the minimum size, a stipulation on maximum size at harvest was eventually enacted, with current law requiring that all lobsters with a carapace measure greater than five inches be returned to the ocean. Both the maximum and minimum size regulations, together with the V-notch law, are aimed at protecting the brood stock. The statute stipulating a minimum measure is designed to permit a female lobster to reach a maturity level that allows for at least one reproductive cycle before it can be legally harvested. The maximum regulation is designed to protect the most prolific breeders and studs. Larger, older lobsters can produce 100,000 or more eggs compared to approximately 10,000 eggs produced by smaller, younger lobsters. Preserving these larger, or "oversized," lobsters provides a greater capacity for breeding and reproduction, thus protecting natural restocking of the resource.

If you were to ask any lobsterman in Maine today about the value of V-notching, he would likely say it is the most important and respected law on the books. Following his many interviews with lobstermen over the years, Dr. Acheson even termed their view of the practice as "sacrosanct."

The view of a minimum and maximum legal size is still debated a bit. Though the concept is nearly universally accepted in Maine (but less so in other states and Canada), there is always ongoing discussion about what the exact minimum and maximum measurements should be. It is stipulated that regulatory groups must use the "best available science" in making these types

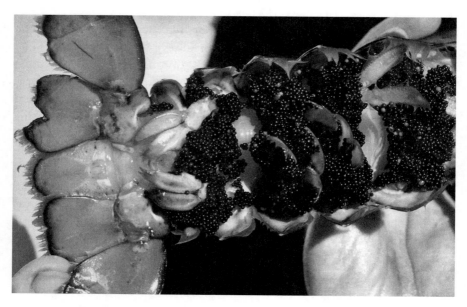

A V-notched berried female carrying eggs on its tail. *Courtesy of Bob Bayer.*

The voluntary protection of egg-bearing females by lobstermen grew even more prevalent after the advent of the seed lobster program. According to research and interviews conducted by Dr. James Acheson, the continued improvement in catch levels from the mid-1930s helped to motivate lobstermen to V-notch, as they gave the V-notch a major amount of the credit. Acheson further noted that V-notching got a big boost when men returning from military service in World War II took up the practice in increased numbers. In his writings, Acheson noted that Eddie Blackmore, past president of the Maine Lobstermen's Association, said, "We decided that if we were going to keep it [the fishery] going, we needed to do something to replenish the supply. We knew that V-notched lobsters were protected, and we decided to put more lobsters in that category. When I had an especially good day, I would notch one or two big-egged females as a way of investing in the future of the industry. We didn't have to do it, but the idea caught on and a lot of people began to preserve the proven eggers in this way."[26]

By the 1980s, the concept of V-notching was almost universally accepted by lobstermen as the most important method sustaining the lobster stocks. A study by Dr. Bob Bayer of the Lobster Institute at the University of Maine showed that in 1995, approximately 60 percent of egg-bearing lobsters were voluntarily V-notched. A similar study in 2000 by Maine's Department

lobster fishery has gained worldwide recognition as a superior model of a sustainable fishery. This is no accident, as Maine's lobstermen have been aware of protecting the resource for future generations for well over a century and a half. As Jon Carter, a fisherman from Bar Harbor, likes to say, "We were conservation before conservation was cool." Long before conservation or sustainability became buzzwords of environmentalists, the lobstermen themselves were taking action to ensure that there would always be lobsters available for their sons and grandsons—and now certainly their daughters and granddaughters, too—who wanted to follow in their footsteps.

The first legal regulation designed to limit the lobster fishery and preserve the resource for Maine's lobstermen was a law passed in 1828 that banned out-of-state lobstermen from fishing in Maine waters. Maine's lobstermen saw this was not going to be sufficient to safeguard the lobster stocks, and as they tell it, they pushed for a law that would legally require a conservation measure that many of the fishermen were already employing. In 1872, the first law banning the landing of egg-bearing lobsters was enacted. This was soon followed in 1874 by a law imposing the first size restrictions on lobster landings, regulating the minimum size of a lobster that could be legally harvested. The first minimum size was ten and a half inches, with the measure taken from just behind the eyes to the end of the tail.

The ban on harvesting egg-bearing lobsters remains in effect to this day. It has been strengthened over the years by the introduction of a practice called V-notching. A lobster is V-notched literally by making a cut in the shape of a "v" in one of its tail fins. The custom of marking egg-bearing females began in the early twentieth century, when lobstermen took it upon themselves to mark any egg-bearing females that were hauled up in their traps and return them to the water. Thereafter, this female was identified as being able to reproduce, and it was common practice to continue returning these marked females to the ocean to bolster the brood stock. For most of the twentieth century, this was a strictly voluntary practice. In 1917, a state-mandated form of a V-notching program was begun for lobsters that would egg-out (extrude their eggs) while being held in tidal lobster pounds. State wardens were allowed to purchase these lobsters from pound owners, mark them with a hole punched into a tail fin and return them to the ocean. Lobstermen were then forbidden from harvesting any lobster with a hole in its tail fin. In 1948, the V-notch method replaced that of punching a hole in the tail fin. This course of action became known as the seed lobster program, and though little exercised today, it is still on the books as a practicable program.

lobstermen—a unique model of co-management was adopted in Maine in 1995. It was one of the first fisheries co-management models in the world and is based on the premise that fishermen and government managers can be jointly responsibly and share in the authority for conserving the lobster resource. As a result of this new way of doing business, the commissioner of DMR was able to create a series of lobster zones along the coast that provided a recognized structure for lobstermen to offer input and even make some of their own decisions regarding certain regulatory issues. Seven such zones are currently in place, established based on geography and historical fishing areas. These zones, labeled A through G (roughly going from east to west down the coast), are represented by an elected Lobster Zone Council. These councils were given the power to propose regulations on such items as trap limits, the number of traps that can be fished per line, limited entry mechanisms and the times of day during which lobstermen can legally fish. In addition, they were given a voice at the table for discussion of state policy through the Lobster Advisory Council. Each Zone Council elects one of its members to serve on the Advisory Council. They are joined by two lobster dealers/wholesalers, one member of the general public and three lobster license holders at-large—all appointed by the commissioner of DMR.

This co-management system, though still relatively young, has met with internationally recognized success. Conservation measures that had never successfully made their way through the legislative process before, such as controlling fishing effort through trap limits, were reasonably proposed by the Zone Councils, approved by the commissioner and passed in the legislature. Without a strong commitment to sustainability, as was and is the case with Maine's lobstermen, it might be difficult for this type of management model to be effective in other fisheries; however, it has set a standard that many are contemplating following.

Managed for Sustainability

It has been over four hundred years since the first recorded lobster catch in Maine, and for nearly two hundred of those years, there has been an active commercial lobster fishery. Over all that time, though there have been some ups and downs, the lobster stocks have remained viable. Indeed, as we have seen, 2010, 2011 and 2012 all brought in record catches. The Maine

> *The lobstermen as such never had a voice in the Legislature. There might be a group from Downeast, or another group from Penobscot Bay, or maybe another from Casco Bay; and they would all have different ideas, so there was no representation.*
>
> *So that's why we got the fellows together all along the coast—so we could have some representation in the Legislature. Two years before that,* [the dealers] *tried to increase the minimum lobster size. The lobstermen from this area, principally from Penobscot Bay, we defeated that legislation. Another group saw that and said, "We need to have some representation." And that's what started the MLA.*
>
> *Lobstermen are the most independent breed of people on the whole earth. They are so damned independent that anything you propose to them that is new or different, they want nothing to do with it. They have their own way of doing things, and it's been handed down from father to son for 200 years. In certain areas, they build a certain type of trap with a certain fishing head. In another area, they'll build a different trap with a different hang to the fishing head, and they'll catch lobsters with that. Anything different from their own way of doing it is no good—that is, until you convince them that it is all right.*[25]

Since its formation in 1954, the MLA has expanded to represent 1,200 members in 2012. Though not a labor union, it has taken an active interest in everything from pricing and minimum size increases to the construction of oil refineries and offshore wind energy farms. In addition to weighing in on such policy issues, the MLA also offers its members benefits such as insurance discounts and deals on a variety of other products. The MLA is now the largest and oldest fishing association on the East Coast. However, as is often true, no one entity can truly be the representative voice of an entire constituent group. This turned out to be the case with the MLA, as other organizations such as the Downeast Lobstermen's Association, which was formed in 1991, and the Southern Maine Lobstermen's Association began to spring up. In fact, each sector within the lobster industry also followed the lead of the MLA. The Maine Lobster Pound Owners' Association was started by Herbert O. Hodgkins, from Tidal Falls Lobster Pound in Hancock, in 1984. This association is now defunct due to a decreasing number of tidal pound owners. The Maine Import/Export Lobster Dealers' Association was formed in 1985, mainly through the efforts of Pete McAleney of New Meadows Lobster in Portland.

In an effort by the fishermen to gain more input into the management process—and an effort by DMR managers to get more buy-in from the

as the Marine Mammal Act, the Endangered Species Act, the Magnuson-Stevens Fisheries Conservation and Management Act and the Sustainable Fisheries Act.

NMFS authorized the Atlantic State's Marine Fisheries Commission (ASMFC), formed in 1942, to oversee federal management of the various commercial fisheries on the East Coast. This working group is composed of three representatives from fifteen eastern seaboard states. These people include the director of the states' marine resources management agency, a state legislator and a fisheries representative appointed by the governor. The member states are responsible for implementing the Commission Plan. The ASMFC has delegated the task of lobster management recommendations to its Lobster Management Board (LMB). Each state with a commercial American lobster fishery has representation on the LMB through the various Lobster Conservation Management Teams (LCMTs) that serve on a lobster advisory panel. Each state is also able to manage its own lobster fisheries, within the overarching federal guidelines, inside the three miles from its shoreline to federal waters. Maine's fisheries are managed by its Department of Marine Resources (DMR), originally called the Department of Sea and Shore Fisheries.

One of the first words used by lobstermen when describing themselves is likely to be "independent." While lobstermen have always respected the need to conserve the lobster resource, they have not traditionally been known to appreciate anyone sticking their noses into their business, particularly the government. In 1954, lobstermen from around the state first decided to combine their voices and their influence to better represent their collective interests by forming a professional organization that could represent them in the policy decision-making process. It was at this time that the Maine Lobstermen's Association (MLA) was formed by Leslie Dyer, a lobsterman from Vinalhaven Island. Dyer began fishing at age eleven and was fifty-six when he became the first president of the MLA, a position he held until 1966. Dyer's goal was to unify the fishermen to gain influence with not only the legislators but also the lobster dealers, who dictated the boat price. Dyer's thoughts on the formation of the MLA were recorded in a 1974 interview by David Taylor that is preserved in the Maine Folklife Center at the University of Maine and excerpted on the MLA's website (www.mainelobstermen.org):

> *The trouble with lobstermen is that they are like...birds or animals of a certain range. When anyone comes into that range, he is an outsider. It's hard for them to see the big picture, the whole length of the coast. What might be good for one group might not work for another group. You couldn't get them to work together.*

CHAPTER 8

SUSTAINABILITY: CONSERVATION BEFORE CONSERVATION WAS COOL

THE CO-MANAGEMENT MODEL

Those who fish for lobsters in the cold waters of the North Atlantic are committed to securing the lobster resource for generations to come. Responsible harvesting of lobster has been a cornerstone of the fishery's conservation efforts for over 136 years. Before one can fully understand all of the conservation regulations, it is helpful to know a bit about the various management agencies and models and advocacy groups that have a huge impact on the fishery.

Given the ecological differences in various fishing areas, there is no simple management solution appropriate for every region, state or country. When it comes to regulations, there is no "one size fits all." However, there are recognized standards, including the Food and Agriculture Organization of the United Nations' Code of Conduct for Responsible Fisheries. Legislated conservation practices based on these standards exemplify the lobster fishery's commitment to sustaining the lobster resource.

Lobster management is full of acronyms that quickly become commonplace in a lobsterman's parlance. The umbrella organization responsible for the management of all U.S. fisheries is the Department of Commerce's National Marine Fisheries Service (NMFS). The American lobster fishery, like all other U.S. fisheries, must abide by such federal laws

to the end of the carapace (or body)—excluding the tail from the measure altogether. However, prohibition of removing a lobster's tail or otherwise dismembering it during processing was still on the books and handcuffed Maine's processors for years, basically restricted them to processing only whole frozen lobster. The lucrative frozen and fresh tail business was out of their reach. This so-called mutilation law was finally removed from Maine statute in 2010 following a recommendation by a special task force appointed by then-governor Paul LePage and charged with finding ways to ensure the economic sustainability of Maine's lobster industry. The legislation, "An Act to Amend the Lobster Meat Laws and Expand Economic Opportunity for Maine's Lobster Industry" (LD 1593), was passed unanimously by the legislature's Marine Resources Committee, was enacted in Maine's House of Representatives with a 145–0 vote and easily breezed through the Senate. The repeal of these restrictions opened up many more product possibilities and profits for Maine lobster processors. While still lagging behind Canada, the number of lobster processors in Maine is now closer to a half dozen and growing. Some say Maine will never outstrip Canada in the processing sector because the Canadian businesses have an established clientele, more governmental support in the way of tax breaks and a more secure and economical workforce given that Canada has a universal healthcare system and processors do not have to supply healthcare benefits. However, being closer to the source has already lured at least one Canadian processor to expand into Maine. The lines might become even more blurred over time.

frozen product in inventory, creating a situation in which the supply far outstripped the demand for their processed product. Boat prices were cut dramatically, with some lobstermen receiving only about $1.25 per pound for their lobsters. To date, the unprecedented profusion of early shedders in 2011 seems to be a bit of an aberration, but it could become a trend to monitor in the coming years.

In continuing to track the market chain, what becomes of Maine's lobsters once they are shipped to Canadian processors? As soon as a Maine lobster is handled in Canada, the country of origin labeling definition changes and the lobster becomes a "Product of Canada." In an ironic twist, once processed in Canada, the United States becomes the importer of the majority of this lobster in its various forms.

> AN 1887 LAW STIPULATED THAT "THE TRAFFIC[KING] IN OR POSSESSION OF SPAWN LOBSTERS OR LOBSTERS LESS THAN 10½ INCHES LONG WHEN ALIVE OR DEAD, COOKED OR UNCOOKED, WAS DECLARED ILLEGAL, AND THE POSSESSION OF MUTILATED, UNCOOKED LOBSTERS MADE PRIMA FACIE EVIDENCE OF THE FACT THAT THE LOBSTER WAS AN ILLEGAL LOBSTER."

This then begs the question of why there isn't more lobster processing done in Maine or even elsewhere in the United States. In fact, there has been an increase in the number of lobster processing facilities in Maine in the past ten years. After lobster canneries disappeared in the late 1800s, and before 2010, there were only one or two lobster processors in Maine at any given time—and the only lobster processing plants in the United States were in Maine. This meant that Canada had about a seventy-five-year head start on developing infrastructure, a workforce and a history of successful processing. This Canadian advantage can be at least partially attributed to an old law on the Maine books that prohibited the separation of a lobster's tail from the rest of its body during processing. This archaic law was based on a management regulation (long ago eliminated from the books) that said the legal measure of a lobster was from the tip of its rostrum (head) to the end of its tail fins.

Therefore, lobsters at processing plants had to remain intact, and if they did not, enforcement officers could automatically declare that the processors possessed lobsters of illegal size. Scientists ultimately found using the measure of the entire lobster to be inaccurate and inconsistent, and it was replaced with a measure from the tip of the rostrum (a point just behind the eyes)

But back to Canada. Why, if Canada lands more lobsters than the United States, are they the largest importers of U.S. lobsters? The answer can be found in the hard-shell/soft-shell dichotomy. As you might recall, 80 to 85 percent of all lobsters harvested in Maine are of the soft-shell variety. By 2012 statistics, this would mean approximately 100 million pounds of soft-shell lobsters were landed in Maine. There is not enough demand to sell these lobsters in the local live market. That leaves processing as the market outlet for all this poundage. The question then becomes: where does all of this processing take place? The answer: the number of Canadian lobster processing plants far exceeds the number of processing plants in the United States. As a result, nearly 70 percent of Maine's lobster catch is exported to Canada and is trucked directly to processing facilities, primarily in New Brunswick and Nova Scotia.

In contrast, an overwhelming percentage of lobsters harvested by Canadian lobstermen are hard-shell lobsters. If it is the same type of lobster, with fishing waters literally side by side, why does this happen? The reason is a difference in fishing seasons. Lobstermen in Maine can fish year-round. On the other side of the border, Canadian lobstermen have very defined seasons during which they are allowed to fish. These seasons vary according to which of the thirty-four Lobster Fishing Areas (LFA) a lobsterman fishes, but all seasons are scheduled to allow fishing when the hard-shell lobsters are most plentiful. Often this means during the colder winter months, when fishing can be rough but the vigor of the lobsters is greatest. In Maine, however, while some lobstermen fish nearly year-round, a great deal of landings are brought in during the warmer months of June through September. This is a time when the water tends to be warmer and the lobsters are molting or recently molted—thus found in a soft-shell state.

A typical schedule for Canadian handlers looks something like this: from mid- to late June until mid-November, Maine product will be processed; then, from early June to December, live product from Canada will be handled (some shipped, some processed and some held for future sale).

As was noted in the previous chapter, in recent years, soft-shell lobsters have been landed in Maine as early as March, April or May, thus increasing the percentage of soft-shell in the overall catch. In 2011, the number of soft-shell lobsters in these spring months was so great that the entire industry was caught off guard. It was not yet tourist season in Maine, so there was no demand in the local markets to absorb this abundance. Processors were not prepared to ramp up production during this normally quiet time in the fishery. Additionally, the processors already had a substantial amount of

CHAPTER 7

IMPORTS AND EXPORTS: THE CANADIAN CONNECTION

Exporting American lobsters has become big business in the United States and Canada. In fact, in 2012, lobsters ranked third on the list for dollar value of all seafood exported from the United States. A ten-year average indicates that the United States lands approximately 44 percent of the *Homarus americanus* catch, while Canada lands the remaining 56 percent. However, the gap has slowly been closing, and 2012 figures indicate that the United States landed 49 percent and Canada 51 percent. Nearly 90 percent of all lobsters landed in the United States are caught in Maine waters; therefore, nearly all lobsters exported from the United States are harvested in Maine.

Interestingly, Canada is the largest importer of U.S. lobster, and the United States is the largest importer of lobster from Canada. After Canada, the top eight importers of American lobster are (in order): Spain, Italy, France, Japan, the United Kingdom, China, South Korea and Belgium. The European countries particularly import a substantial amount of lobsters during the Christmas season, as it is a traditional favorite indulgence during the holidays.

Due to federal regulations surrounding safety inspections and product labeling, the vast majority of Maine's live lobsters exported overseas are labeled as "Boston lobster." This is because the bulk of the shipping to Europe and Asia flows through Logan Airport in Boston, Massachusetts, as Maine lacks adequate infrastructure to economically transport lobsters and handle the amount of live shipping in freight planes.

in Milford, Connecticut. Others say it was the now-defunct Nautilus Tea Room in Marblehead, Massachusetts. It is Bayley's Lobster Pound in Pine Point that, while not claiming to have invented them, does lay claim to being the first to offer lobster rolls on its menu in Maine.[24] With the availability of freshly caught and then flash-frozen tails and meat, these mainstays can be found on restaurant menus or on cruise ships at any time of the year. Indeed, in the past five years, the lobster roll has found its way inland and away from the East Coast to become a "new" favorite in restaurants from New York to California.

The lobster harvest has increased dramatically over the last twenty-five years. Maine's landings have risen from just over 19.7 million pounds in 1987 to over 126.7 million pounds in 2012. That's more than a 600 percent increase. Soft-shell lobsters, which used to be caught in June or July, are now being found in Maine waters in the early spring. With such an increase in landings, the amount of lobster available for processing has jumped considerably. With the increase in supply, the entire industry has been looking for ways to increase demand. Use of lobster meat as an ingredient has burgeoned not only in restaurants but also in direct retail to the end consumer. Everything from lobster primavera to lobster mac and cheese can be found on customers' plates at casual-dining restaurants such as Red Lobster, Outback Steakhouse and Ruby Tuesday. More forms of lobster are finding their way onto dinner plates at home as well. Not only can you find simple bags of lobster meat at your seafood counter, but you can also find more unique products such as lobster for smoking on cedar planks and cocktail claws for dipping in the sauce of your choice. Economists say these types of value-added products are creating a path for future growth in the lobster market. They are likely the best way to increase demand, move product and ensure a good price all the way through the market chain right down to the fisherman's boat price.

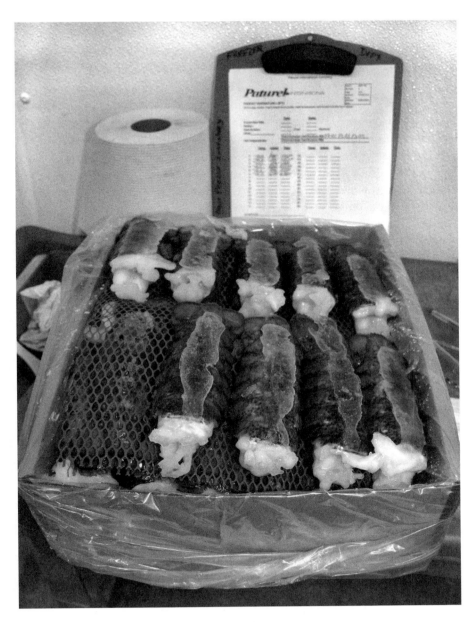
Frozen lobster tails ready for packing for wholesale.

As noted, the dealer will move his soft-shell product to either a local live market, such as nearby restaurants or grocery stores, or to processors. A processor can handle the lobsters in many different ways to create a product line, which might include whole frozen (cooked or uncooked) in the shell, fresh or frozen tails (cooked or uncooked) in the shell and bags of fresh or frozen cooked and picked meat (see Chapter 5). Steaming is the typical method for cooking lobsters at processing plants. A conveyor belt system is used to move the lobsters through the cooking process. Whole lobsters are graded and separated by weight either by hand or, in larger plants, mechanically. In an automated system, which has sensor scales built into a conveyor belt, lobsters are sorted out and directed down shoots to collection bins according to their weight.

New to the lobster processing arena are two technologies that were introduced in the early 2000s. The tried and true method of pasteurization was applied to cooked lobster meat by East Coast Seafood. Once pasteurized and vacuum-packed, lobster meat gained a greatly extended shelf life on grocery store shelves and in restaurant freezers. Shuck's of Maine was the first to bring a new high-pressure technique to the processing sector. Using this method, lobster meat can be separated from its shell uncooked. This allows for raw lobster meat to be sold to food service companies and chefs, thereby eliminating the double-cooking of lobster meat used as an ingredient in restaurant dishes. Currently, this is a niche market, but there is plenty of room for growth.

Processed to Plate

In the early years of lobster processing, the majority of the demand came from the food service and restaurant businesses. Frozen lobsters and tails have long been a staple on cruise ships and at Las Vegas casinos. Whole lobster tails served with a juicy steak as part of a traditional surf-and-turf entrée have been featured on the menus of white-linen restaurants for decades.

Classic lobster rolls—luscious chunks of handpicked meat and just a touch of mayonnaise served on a top-split hotdog roll—have been sold at seaside shacks and restaurants along the New England coast since the 1920s. There is no clear documentation of who invented the lobster roll. Some say it was Harry Perry, who first dished up morsels of lobster on a bun in his restaurant

Drip rooms are used for storing live lobsters in crates.

Small-scale commercial lobster steamer.

to a second-tier dealer or to a buyer linked directly with either a wholesaler of live lobster or a processor or both. Lobsters are typically trucked from the wharf to the shipping center or processing plant.

In the live market, the wholesaler has several avenues for sales. He may sell and ship the product to importers or food service companies or directly to restaurants, supermarkets, etc. Again, the hardier the lobster, the farther it can be shipped—to such foreign markets as Europe and Asia, for example. Within the United States, unless the markets are close enough for trucking, airfreight is employed to keep the live product at its optimum vigor. Given the right conditions of packing, temperature and moisture, live lobsters can handle a two- to three-day shipping time. These constraints minimize the ability to ship to Asian markets from the northeastern United States and Maritime Canada.

Most of the largest wholesalers and distributors will have saltwater holding facilities for live lobsters. They will typically float their lobsters in crates placed in low tanks, which are filled with recirculating seawater that is temperature controlled and well aerated. They might also use temperature-controlled drip rooms where crates are stacked and provided with a constant flow of water streaming over them.

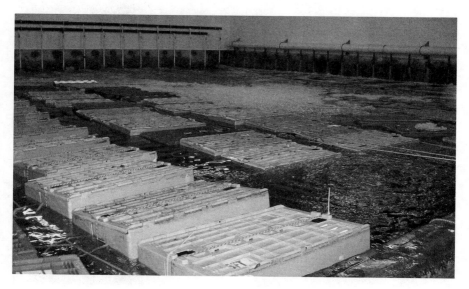

Crates full of lobsters floating in tanks at a processing plant.

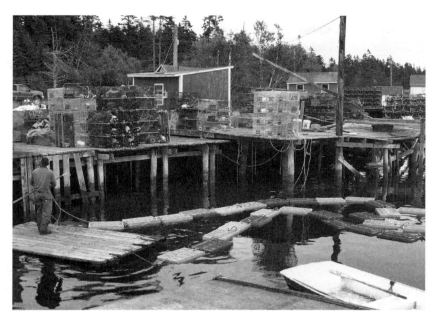

Floating crates full of lobsters waiting to be loaded onto trucks.

Loading lobster crates at the dealer's wharf into a shipping truck at Bunkers Harbor.

A History of Culture, Conservation and Commerce

sold either to a local live market or sent to a lobster processing facility. It is only the hard-shell lobster that has the strength to be shipped any distance in the live market and maintain its vigor. The live market is robust enough to absorb essentially all of the hard-shell lobsters landed in both the United States and Canada. Given the demand, the hard-shell lobster commands a higher boat price paid to lobstermen—sometimes two dollars more per pound than the soft-shell. However, the soft-shell catch in Maine accounts for approximately 80–85 percent of the landings.[23]

Live or Processed

So, where does a lobster go once purchased by the dealer at the wharf? The dealer will weigh the lobstermen's daily catch right at the dock and temporarily store the lobsters in crates that will float in a string (several crates connected by rope) right from the wharf. At the end of the day, these crates are transferred either to trucks or to a holding pound. The dealer might sell

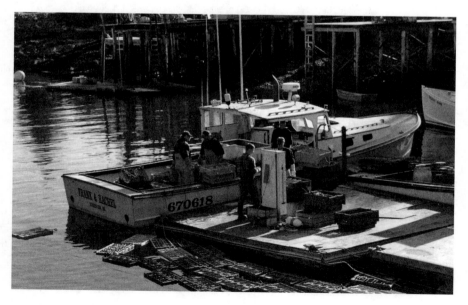

Lobstermen weigh in their day's catch with lobster dealer Dana Rice at his Bunkers Harbor wharf.

they are being treated fairly. As Ed Drisko of New Harbor puts it, "What the co-op has done is give us a window into that crooked marketing system."

Cooperatives have also forced private dealers to increase their services to fishermen. After 1975, when it became obvious that the cooperatives were succeeding and more were being considered, dealers became especially attentive to their fishermen. But the irony remains. Cooperatives, which were formed to help their members, may now be doing more to help the fishermen who have refused to join them.[22]

Today, some lobstermen may bypass the dealer and the rest of the buying chain altogether to sell directly to restaurant owners or consumers looking for live lobsters. This is not the norm, but it can be a way for a lobsterman to get a better per-pound price for his catch. With lobster landings of over 200 million pounds to be sold each year, these types of sales could never move a reasonable percentage of the supply. Additionally, it also means the lobsterman would have multiple jobs—a long day of fishing, followed by a job as salesman and delivery driver. This does not appeal to the majority of lobstermen.

Hard-Shell or Soft-Shell

When lobsters are brought to the dealer's wharf, they are sorted by soft-shell (newly molted) versus hard-shell. The soft-shell lobster, sometimes called a "new shell" or "shedder," has less vitality than a hard-shell and must be

Crates of lobsters arrive at the processing plant.

administering a co-op is time consuming, and organizational meetings can be tedious and argumentative. (As the time-honored joke goes, get three lobstermen in a room and you'll get four opinions.) Lobstermen also lacked the experience in purchasing, sales and marketing that their dealers had. They tended to hire managers whom they knew and trusted rather than someone with the best qualifications for the day-to-day responsibilities of the job.

It was also difficult, in some cases, to overcome the loyalty lobstermen felt toward their dealers. There were fears that if they joined a co-op, they might lose access to the water and be kept from acquiring enough bait. It was also hard to give up the possibility of bonuses and special incentives, such as access to loans, which dealers could provide. Several co-ops worked with Howard Clayton, a lawyer from Damariscotta, to overcome some of these challenges. With Clayton's guidance, the Fishermen's Credit Union was formed. This gave lobstermen a fair shot at acquiring loans without committing themselves to a dealer. Clayton also helped form the Maine Association of Cooperatives (MAC) in the mid-1970s to offer marketing services to participating co-ops. Ten cooperatives joined the association, which soon began shipping their live lobsters worldwide, circumventing even the distributors. Under the auspices of the MAC, a lobster processing plant was opened at Spruce Head, and lobstermen struck a deal with the state that allowed them first priority to alewife streams to fish for bait.

Early fiscal struggles, coupled with few capital investments, hampered the MAC. It was eventually forced to disband following a devastating economic loss when a substantial shipment of its live lobsters was rerouted due to an engine failure in the plane that was carrying them overseas. This unforeseen change in schedule ultimately resulted in the loss of the entire shipment. The MAC was eventually compensated for the loss by the airline, but due to the immediate monetary strain, it was driven to closure.

Even with the loss of the MAC, a solid number of individual co-ops remain active in the lobster industry. Today, there are close to twenty lobster co-ops still active. It's been said that even those lobstermen who are not members of a co-op have benefitted from this movement. Dr. James Acheson, an anthropologist from the University of Maine, notes:

> *The formation of cooperatives has lifted the veil of secrecy from prices and markets. Since it is common knowledge that the cooperative managers try to get as high a price as possible for their members, the cooperative prices have become the benchmark used by all fishermen in Maine to assess whether or not*

The lobster co-op on Cranberry Island. *Courtesy of Bob Bayer.*

lobstermen of the region formed the Pemaquid Harbor Cooperative, which was said to be the first fishermen's co-op in the country. This was followed shortly thereafter by co-ops in Boothbay and Stonington. These co-ops were designed so that lobstermen could band together to share in the costs and profits of basically running their own dealership. The theory was that instead of their catch going to line the pockets of dealers, the lobstermen could maximize their profits and minimize their expenses.

Cooperatives could buy supplies, fuel and bait for their members and sell them at cost—or at least at just enough profit to pay a manager to run the co-op. The manager would work for the lobstermen and be able to pay them a boat price that better reflected the market. As a member of a co-op, a lobsterman would also have clear access to the waterfront via the co-op's wharf. Less so in the early days of co-ops, waterfront access today is a precious commodity.

The number of co-ops saw a modest increase in the 1970s. Lobstermen have always liked the idea of being their own boss, and the independence from dealers that the co-ops offered was appealing to some. The opportunity to have a manager looking out for their best interests and trying to get them the best boat price was also attractive.

Starting a co-op had is challenges. Prime among these was the start-up cost of acquiring a location and hiring a manager. Again, this is tougher today due to the expense of waterfront property for a wharf/buying station. Additionally,

A History of Culture, Conservation and Commerce

Dana: How do you think Harry's reaction would be if they came back now and saw what the price is and the boats and everything?

Alison: They would look up and look at the boats and some of the catches, and they would almost lose their breath.

Dana: Yes, yes they would.

Alison: They really would.

Dana: It's hard to believe in our lifetime that we've seen the changes we've seen in the lobster fishery.

Alison: Yes…yes.

Dana: It's pretty hard to…to just sink that into your head.

In 1880, Maine's Department of Marine Resources recorded that the price per pound of lobster landings averaged just $0.02. By 1905, it had reached double digits at $0.13. The first time the average annual price per pound cracked $0.50 wasn't until 1959. The $1.00-per-pound milestone was not reached until 1971, and the highest annual price per pound recorded was $4.63 in 2005. Of course, individual lobstermen on any given day might have received more or less per pound than the recorded average during any given year.

Co-ops and Other Options

Lobstermen's relationships with dealers can be called bittersweet. They rely on one another, yet they historically have not seen eye to eye, particularly in regard to price. The thought that dealers collude on setting a low boat price has reared its ugly head on many occasions. Always an enterprising group, lobstermen looked for ways to bypass the supposed monopoly of the dealers. In 1947, the concept of cooperatives (or co-ops, as they are called) found its way into the lobster industry. The first lobster co-op was established in that year at Pemaquid Harbor, spearheaded by James Brackett. The

dock. He later bought his first motorized boat for $350.00. He recalled how his parents allowed him to buy only one soda per year, and that was on the Fourth of July. It would cost him $0.04. Bait cost Robert $0.10 a bushel, and he was paid $0.10 to $0.14 for his lobsters.

Harvey Crowley lobstered out of Beals Island, Maine. He started working when, as he put it, "I could carry a clam hoe." He, too, started lobstering at age eight, in the 1930s. He would get $0.25 a pound for lobsters he hauled up in his six or seven traps.

Alison Bishop, a gentleman from Corea, Maine, also started fishing in the 1930s. He recollected that at that time, milk was $0.10 a quart and bread was $0.05 a loaf. His first boat set him back $1,400.00. He remembered paying $0.50 a bushel for herring bait and receiving a $0.38-per-pound boat price. He and good friend Dana Rice spoke of the first time the boat price for lobster went over $1.00. Here's how the conversation went:

> *Alison: We'll go back up to when I first started. In the winter months, course the days were short and all day you couldn't haul too many traps. But if you could go out and get anywhere from twenty-five to fifty pounds through January and February, you had a good catch.*
>
> *Dana: Yes.*
>
> *Alison: And you didn't get no big price for them either. When lobster got up to $1.50 a pound, you had it made. That was somethin' else.*
>
> *Dana: Yes, tall cotton then.*
>
> *Alison: Yes, that was somethin' else.*
>
> *Dana: I heard my grandfather say more than once, "Chum, you'll never see lobsters go up to one dollar a pound 'cuz nobody will ever be able to afford to eat them."*
>
> *Alison: My father would've agreed. The day…the day that he got one dollar a pound for his lobster…when they told him what the price was, he couldn't believe it. In fact, there was a fisherman in Corea standing on the wharf when he came in, and he looked down and said, "Harry, you're never going to believe what the price of lobster is today." He told him one dollar a pound.*

CHAPTER 6

GETTING FROM THE LOBSTERMEN'S TRAPS TO YOUR TABLE: WHO IS HANDLING YOUR LOBSTER?

LOBSTERMAN TO DEALER

Once a lobsterman hauls his traps, the trip from the boat to the dinner plate (or picnic) can take several different routes, with varying layers of complexity. Most lobstermen will work with the dealer (or buyer) at the wharf in the harbor where they moor their boats. The dealer will also supply the lobstermen with their bait and fuel at this same wharf. These dealers typically have a loyal group of lobstermen with whom they work from season to season, who don't shop around too much for the dealer with the best price. A solid working relationship is more important—this has held true since the commercial lobster fishery began. Often a dealer will keep daily records of the number of pounds brought to the dock by each lobsterman and then settle up payment once a week. At the end of the season—given quality landings, successful sales and a good economy—dealers might also provide their lobstermen with bonuses.

As one could imagine, looking historically at prices paid to lobstermen by their dealers (boat price) shows quite a swing. In interviews as part of the Lobster Institute's Oral History Project, lobstermen were asked when they first started lobstering, what the boat price was at the time and what some other items cost.

Maine lobsterman Robert Joyce from Swan's Island said he started fishing at age eight, in the late 1920s, with eight to ten traps. He relayed with pride how he paid $1.00 for his first wooden skiff, a rickety old thing that began falling apart as soon as he and his father starting towing it back to their own

Yes, even the walking legs of the lobsters are processed for their meat.

allowed for IQF or "individually quick frozen" products. In addition to being a timesaving innovation, it also allowed for a deeper freeze and thus longer shipping times, allowing for a farther reach to distant markets. While you can still find popsicle lobsters, today's frozen lobster products also include whole cooked lobster without brine, whole uncooked lobsters, cocktail lobster claws (partially shelled), ice-glazed lobster tails or claws and arms (raw or cooked) and bags of cooked picked meat. The demand and asking price for whole tails is greater than that of bags of meat; therefore, tails are typically kept whole, and it is primarily the claws, knuckles and sometimes the legs that are picked for their meat. In the wholesale market, these bags of meat are referred to as CK or CKL. Cooked lobster meat has always been picked by hand, with very little change in technique over the years.

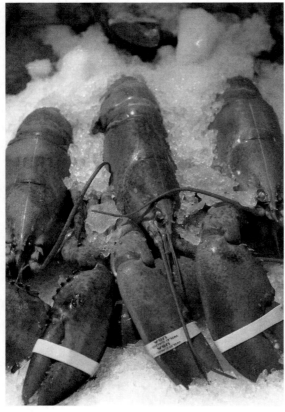

Above: A huge tank of liquid nitrogen, which is used to fuel cryogenic freezers.

Left: Whole cooked lobsters.

The Maine Lobster Industry

Left: Boxes of frozen lobsters waiting to be shipped by East Coast Seafood.

Below: Cryogenic freezer used at lobster processing plants.

LOBSTER GAINS A WORLDWIDE REACH

An innovation that changed the entire complexion of the lobster industry was introduced in 1936 when Emile Paturel first started freezing lobsters in his processing plant in Canada. Paturel was a contemporary of Clarence Birdseye (of Birdseye frozen vegetables fame), whom it is said encouraged him to employ the freezing technique with lobsters. There is still a plant in Deer Island, New Brunswick, that bears his name: Paturel International Company. The first frozen product was the "Popsicle Pack," a whole cooked lobster sealed in a bag with saltwater brine.

Frozen lobsters could be shipped across the United States by rail, and with a boom in shipping by air in the 1950s, frozen American lobsters began to develop a worldwide market. As airplane technology evolved, flight times became shorter. This also allowed live lobster to be shipped as far as California to the west and Europe to the east. Shipping live lobsters to Asian markets remains a challenge because of the additional one to two days in the shipping process. However, frozen lobsters can easily reach fish markets in Hong Kong, Japan, Korea and China. The Asian culture and palate still prefer a live product, so the quest to consistently bring vigorous live lobsters to these markets is ongoing.

Cryogenic freezing, or blast freezing at extremely low temperatures using liquid nitrogen, was introduced to the lobster industry in the 1980s. This

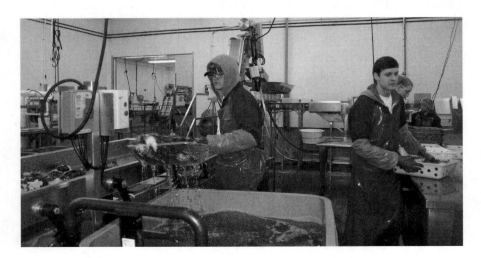

Lobster tails in brine go onto the processing line to be packed for wholesale.

Lobster was actually the first food to be canned in Maine, and it was only the second time any food was canned in all of America. Maine's first lobster cannery (which also canned salmon) was opened in Eastport by Upham S. Treat in 1842.

At that time, a one-pound can of lobster meat (equal to the meat from approximately six one-pound live lobsters) sold for three cents. The demand was quite strong, and by the 1870s, there were as many as twenty-three lobster canneries operating in Maine at any one time. Maine's lobstermen were still fishing from dories propelled by sail and oars at this time. This meant that lobstermen stayed close to shore and typically hauled only about twenty-five to fifty traps each day, with an average of seven four- to six-pound lobsters in each trap.[21] It did not take long for the demand to start outstripping the supply. Soon smaller and smaller lobsters were being harvested to fill the needs of the canneries. In fact, lobsters of less than a pound came to be called "canners." The harvesting of canners began to take its toll on the lobster stocks. The youngsters were being caught and canned before they had the chance to go through a reproductive cycle and contribute to the sustainability of the stocks. Some say it was the fishermen themselves who sounded the alarm and called for protections to secure the fishery. However it came about, the first legal restrictions on the lobster fishery aimed at conservation were enacted in Maine in 1872, when a law was passed that banned the landing of egg-bearing females. Shortly thereafter, in 1874, a law was enacted that placed a minimum size restriction on harvesting lobsters. Lobsters under ten and half inches in total length, from the end of the tail to the tip of the claw, were declared too small (young) to be landed. These restrictions were put in place to both protect the brood stock and to protect young lobsters up to the point where they might conceivably go through at least one reproduction cycle. Before sustainability was the buzzword that it is today, lobstermen were ahead of the curve in protecting their stocks—and their livelihood.

These protections likely saved the lobster fishery, but they were the beginning of the end of the booming lobster cannery business. By 1885, nearly all the lobster canneries in Maine were out of business. Hot-pack canning did continue on a very limited basis in Maine until the 1970s, when it was supplanted by cold-pack canning. Without the need to heat the lobster meat as part of the canning process, the quality of canned meat improved, but the appeal of canned lobster has never truly rebounded from its heyday of the mid-1880s.

GOVERNOR JAMES P. BAXTER (ALSO A PARTNER IN THE PORTLAND PACKING COMPANY) SHEDS LIGHT ON THE START OF THE CANNING INDUSTRY IN MAINE IN THIS EXCERPT FROM THE 1918 BIENNIAL REPORT OF THE COMMISSION OF SEA AND SHORE FISHERIES, IN WHICH HE TALKS OF A PATENT DEFENSE TRIAL REGARDING CANNING METHODS:

This was Mr. Treat's testimony under oath in the U.S. Court in 1871, after he had retired from business. He packed his goods under what was called the Appert method—after Appert, the Frenchman who invented the process of hermetically sealing provisions. Isaac Winslow, of Philadelphia, who resided in France for a number of years, became acquainted with the French products, which covered vegetables, fruits, fish and meats, and he conceived the idea of hermetically sealing green corn, and on his return to this country began experiments for the preservation of it, which required a different treatment from other vegetable products. He therefore obtained a patent for his process of preserving green corn. According to testimony in defense of his patent in 1871, John Winslow Jones, a nephew of Isaac Winslow—to whom the patent had been assigned—testified under oath that, with his uncle Isaac Winslow, he took part in his experiments from 1838 to 1842. It is probable that Mr. Treat, knowing of the Isaac Winslow operations, was prompted to undertake the business of preserving fish as a marketable commodity.

The [canning] business in Maine, therefore, for about ten years previous to 1871, was principally conducted by the three firms: the Portland Packing Company, John Winslow Jones and Burnham & Morrill. And during that period numerous factories were built throughout Maine and the British Provinces, in which the Portland Packing Company took the lead, having at one time over thirty factories in operation, a considerable number being in the Provinces.

The great value to humanity of hermetically sealed products has been proved in the recent Great War, as large quantities can be readily transported to distant points at minimum rates of freight. Immense quantities of so-called "canned goods" have been supplied to the starving people of Europe, especially baked beans, a New England product, which has proved of great value to the starving Belgians and others who have suffered from German invasion.[20]

THE MAINE LOBSTER INDUSTRY

Maine governor Edmund Muskie (center) with Claramae Turner (left) and Shirley Jones (right) (stars in the film *Carousel*) at The Lobster, a restaurant where the first Downeast lobster bake in New York was staged. *Courtesy of Maine State Archives (via the Lobster Institute).*

helped spread the fame of Maine's king of crustaceans. If the Rockefellers dined on lobsters, everyone else wanted to follow suit. Soon the demand spread beyond the borders of Maine and the confines of the summer months. Suddenly, lobster was a luxury item that had transitioned from the ordinary to the extraordinary. It was enjoyed by movie stars and politicians. Lobster was a must-have on the tables at special events in Hollywood, the casinos in Las Vegas and at the posh gatherings of the rich and famous in New York City.

CANNING HELPS MEET THE DEMAND

The second factor that significantly expanded the markets in the mid-1800s was the advent of canned lobster, the first form of processed lobster. A live lobster has to be cooked and consumed within one or two days of purchase. With processing came the opportunity to create an extended shelf life for lobster products. The technology of hot-pack canning was invented in France and found its way to the United States in the 1840s.

CHAPTER 5

ACCOLADES AND INNOVATIONS EXPAND THE MARKET

FROM ORDINARY TO EXTRAORDINARY

The live lobster trade was a steady business, albeit only a regional one in the 1800s. Lobster smacks regularly brought Maine lobsters to the markets of Boston, New York and Philadelphia. This was about the farthest reach of Maine's live lobster trade. The lobster had yet to reach its current esteemed status as a culinary delicacy. Indeed, it was still considered common and was used mostly in sauces, salads and stews. As late at the 1870s, a three-pound live lobster would fetch only about three cents.

There were two factors that triggered a significant expansion of the lobster market. The first was an influx of wealthy summer visitors to the Maine coast, who came to escape the heat and dust of the larger cities of New York and Philadelphia. They traveled first by stagecoach and schooner and later by train to the many resort hotels and summer "cottages" dotting the seaboard in such places as York, Ogunquit, Boothbay Harbor, Winter Harbor and Bar Harbor. By the 1880s, over 100,000 tourists visited Maine's seashore resorts,[19] and lobsters were the seafood of choice. This was reinforced by the Rockefellers, one of the most wealthy and influential families in the United States in the late nineteenth and early twentieth centuries. They made their mark and their fortunes in oil, industry, banking and politics. Mount Desert Island was and still is the summer home of the Rockefellers (U.S. vice president Nelson Rockefeller was born in Bar Harbor). It is said they greatly

each year. (The price of gasoline or diesel fuel actually came in a distant second at an average of $7,500 per year—though this gap might have closed a bit with the dramatic increase in fuel prices in 2008 and thereafter.)

A lobsterman will typically purchase his bait right at the same wharf and from the same dealer to whom he sells his catch. Some lobster dealers have their own bait-fishing vessels, but many purchase bait from specialized bait dealers.

Most lobstermen have relied on the tried and true fish baits through the years, but there are an adventurous few who have attempted to find novel and, hopefully, more effective baits. Stories tell of lobstermen using cloth or sanitary napkins soaked in herring oil, bricks soaked in kerosene and any number of animal hides or carcasses. In the 1940s, a company called LobLure was the first to begin commercial product development in what has come to be termed "alternative baits." Dr. Bob Bayer, executive director of the Lobster Institute at the University of Maine, has also been researching and testing alternative baits since the 1980s. Science tells us that lobsters are attracted to protein, or more specifically, the amino acids within the proteins. Therefore, alternative protein sources such as soybeans and a variety of gelatins mixed with fish oils or meals have been tested. While these trials have met with some measure of success, there is still nothing commercially available that is a suitable and economical replacement for fish as lobster bait. However, the search does continue—and rightfully so. With stricter quotas imposed on herring catches in the 1990s and early 2000s—together with the plethora of traps in Maine waters—the supply of herring is barely meeting the demand.

Dana Rice, a lobster dealer and bait supplier, was heard to say at a Lobster Institute's board of advisors meeting, "Pretty soon lobstermen will be pulling shingles off their roof, painting a picture of a herring on them and putting them in their trap as bait."

Excluding major purchases such as the boat, insurance and the traps, some lobstermen say the average cost of just one day on the water is about $600, including paying for fuel, bait and the cost of a sternman. With the price per pound being paid to lobstermen when they sell their catch to a dealer at the wharf (also known as "boat price") ranging from $2 to $4 a pound (depending on the current supply and hard-shell/soft-shell status of the catch), it takes a lot of lobsters to make a living.

A History of Culture, Conservation and Commerce

Above: Barrels of bait waiting to be loaded onto lobster boats in Rockland.

Left: Lowering buckets of bait by hand at Bunkers Harbor.

In addition to outfitting his traps and boat, a lobsterman must also outfit himself with the proper gear. A solid pair of waterproof rubber boots is essential, as are heavy-duty rubber gloves capable of holding up to the handling of hundreds of wet, gnarly lobsters each day. Standard garb also includes a good set of oilskins. These are the weatherproof coveralls and slickers (usually orange or yellow) that protect the lobsterman from the elements. Originally, these were made of sturdy canvas or leather that was dipped in oil to make the garments water resistant. Though the dipping in oil is a practice long gone, and canvas and leather have been replaced by rubberized material, the outfit is still called an oilskin to this day. While worn for practical reasons, the look has become classic and is seen in nearly every photo or painting depicting a lobsterman.

Should the unthinkable happen, and a lobsterman needs to abandon ship, many now carry a submersion safety suit on board that they can don in an emergency to keep them warm and dry in frigid ocean waters until they are rescued.

All About Bait

It is a common misconception that lobsters are scavengers and will eat just about anything, including rotten fish. In fact, though they are not connoisseurs, lobsters do prefer their food fresh and wholesome. Therefore, providing bait to entice the lobster into a trap has become an essential part of the lobster industry. With 3 million traps in Maine waters alone, the bait business is substantial. Bait dealers often have to scramble to meet the demands of the fishery. The bait of choice in most regions is herring. It is sold by the barrel, salted and fresh-frozen. Between the United States and Canada, approximately 700 to 800 million pounds of herring are used as lobster bait each year, and the demand is being met more and more with a "just in time" supply, with no surplus. Those lobstermen who don't use herring (or those who do when herring is in short supply) might bait their traps with a variety of other fish such as redfish, mackerel and others. The cost of keeping bait in the traps is possibly the greatest annual expense a lobsterman will incur. A 2005 survey by the Gulf of Maine Research Institute revealed that the average cost of bait per year is $11,363.[18] With a price of about $100 a barrel, this translates to about 113 barrels used per lobsterman

A History of Culture, Conservation and Commerce

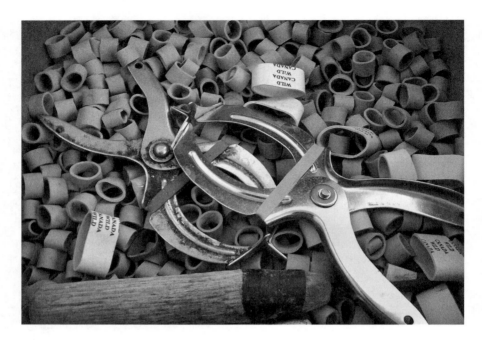

Claw bands and banding tool.

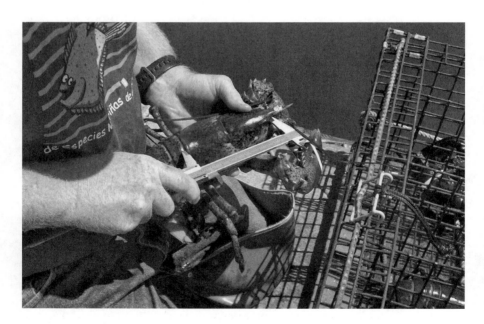

Measuring the lobster's carapace to ensure it meets the minimum and maximum size limits.

Every lobster trap buoy carries the lobsterman's signature colors.

been used for brand identification and for federal origin of product labeling requirements (i.e. "Product of USA" or "Product of Canada"). Before bands were used, wooden pegs or plugs were wedged into claws to prevent them from opening and closing.

Also necessary is a measuring tool, typically made of brass or heavy-gauge steel. This tool demarcates the legal minimum size for landing lobsters on one side and the maximum size on the other. In Maine, the minimum allowable harvesting size is a three-and-one-quarter-inch carapace measure (the carapace being the body shell from behind the eyes to the start of the tail). The maximum allowable size for harvest is a five-inch measure of the carapace. Most lobstermen will keep a measuring gauge tied right to the boat near the gunwale where they pull up their traps. Similarly, a "V-notch" tool (not unlike a paper hole punch) is an instrument used to clip a V-shaped notch in a tailfin (second to the right when looking at the top of the lobster) of any lobster brought up in a trap that is carrying eggs. As a conservation measure, it is illegal to land these "eggers," as they are called. The notching is required by law, and once notched, these lobsters must be returned to the water. Thereafter, any time a lobster with a notched tail is caught, the lobsterman will know it is capable of reproducing and must be released.

and lower maintenance of wire lobster traps. Today, the number of trap tags issued to Maine's more than five thousand licensed commercial lobstermen is over 3 million. Each tag costs the lobsterman fifty cents.

It takes several more items to properly "gear up" for lobstering. No lobsterman, no matter how accurate his GPS might be, would be able to find, much less haul, his traps without buoys and trap lines. A buoy is the floating marker that attaches to a trapline or rope, which in turn attaches directly to the trap or string of traps sitting on the bottom of the ocean. Buoys are somewhat bullet-shaped and originally were made of wood. Many were hand-carved and painted by the lobsterman himself. Each lobsterman must register his buoys' color pattern with the DMR. This practice not only allows fishermen to identify their own traplines, but it also allows for more accurate enforcement of trap limits. Today, buoys are typically made of a compact Styrofoam-like material. Cotton ropes have given way to a nylon blend for use as traplines. Until recently, the lines that ran between a string of traps being fished as a trawl were designed to be light enough to float, thus creating an arc-like connection of rope between traps. Due to the concerns of some environmentalists, a new federal regulation eliminating this "floating line" was enacted in 2009 in hopes of preventing endangered right whales from being snagged in the trawls. These whales migrate regularly from Florida up to Canada and actually spend very little time swimming in Maine waters. However, the law now states that only "sinking rope" that will settle to the ocean floor between traps is allowed going forward. Lobstermen were given several months to change out all of their floating rope, at considerable expense. Additionally, many lobstermen now must replace their rope more frequently, as the sinking rope will chafe considerably if fished on a rocky bottom. This adds to the cost of fishing as well as the workload.

Other "must have" tools of the trade beyond the trap include a dependable knife, which has a number of uses, the most invaluable being to cut away any trapline that might find itself entangled with the feet and legs of the lobsterman; a gaff or hook, which is needed to snag the buoy and trapline as the lobster boat pulls up alongside a trap that is ready to haul (in Maine, the hauling of a trap will usually take place within two or three days of "soak time" after being set); safety gear such as fire extinguishers, etc.; and rubber bands and a banding tool (sometimes called banding pliers), used to place the bands on the claws of all lobsters being landed. Banding is done not only to protect the people who will handle that lobster but also to protect the cannibalistic lobsters from one another. Recently, bands have also

Above: James M. Knott and Dr. Bob Bayer at the Riverdale Mills plant in Northbridge, Massachusetts, where coated wire is fabricated for use in lobster traps.

Left: Spools of different colored trap wire await shipment at Riverdale Mills.

basis for the use of wire was that it was not only considerably lighter out of water as compared to water-logged wooden traps but also heavier and more stable in the water since it was less buoyant than wood. This made wire traps easier to maneuver on the boat and better able to sink to the bottom when set. As is human nature, lobstermen were reluctant to change their way of doing business—thus it took nearly twenty years for this innovation to really take hold in the industry. Once a lobsterman adopted the use of the wire trap, he was quick to discover that it did not need to be pulled from the water for annual repairs. While the state of Maine has never had a defined lobster season, it was the durability of the wire lobster trap that really led to some lobstermen fishing year-round. The only thing holding them back would be the cold and stormy Maine weather.

Knott went on to build a company, Riverdale Mills, in Northbridge, Massachusetts, that remains the primary source of the coated wire used in lobster traps. His wire, which comes in a multitude of colors, is used in such other applications as security fencing and landscaping, but lobstering and building traps remain Mr. Knott's passions.

With the burgeoning use of wire traps in the 1970s, trap building became a major business within the industry as a whole. Today, a lobsterman can choose to buy a kit with all of the components used to build his own trap. However, it is more likely that a lobsterman will buy directly from a trap builder or marine supplier. A relatively small trap of about four feet in length will cost a lobsterman approximately $80. There are seven different management areas in Maine, called lobster zones (Zones A–G). Each zone, working with the State of Maine's Department of Marine Resources, has a say in imposing certain regulations that best fit its geographic and ecological area and has a limit on the number of traps a lobsterman is allowed to fish at any one time. Maine's DMR issues trap tags each year to every fisherman according to the number of traps he chooses to set. Most areas have an eight-hundred-trap limit (none has a higher limit, though some do have a lower limit). Using $80 as a standard price for traps, this would mean the average fisherman has $64,000 invested in traps alone. Many will have a higher amount invested as they might use considerably bigger and more expensive traps. Even given the upfront costs, it was certainly a financial and physical blessing when wire traps eliminated the need for repair or replacement each year. Many wire traps will fish "as is" for a number of years, with only minor repairs to heads and escape vents. Between 1967 and 1997, the Maine Department of Marine Resources' statistics show a doubling in the number of traps fished. Many attribute this, at least in part, to the ease of handling

Traps ready to load up for setting.

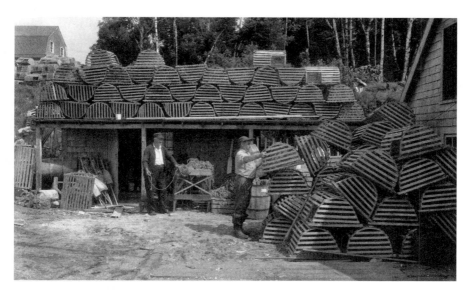

Wooden lobster traps in Harpswell, 1947. *Courtesy of Maine State Archives (via the Lobster Institute).*

Lath traps gave way to wooden parlor traps in the 1930s. A parlor trap has two distinct compartments or parlors. The one that allows lobsters easiest entry into the trap is called the "kitchen." This is where the bait is placed, typically strung in a knitted bait bag from the top of the trap. Lured by the bait, a lobster will enter the kitchen through an opening on the side of the trap called the "head." The head is made of woven twine netting with an opening large enough for a sizeable lobster to enter, which then narrows in a funnel-like fashion to a smaller point of entry fitted with a hog ring. Once the lobster drops into the trap through the hog ring, it is a bit more difficult, though not impossible, to exit the trap. To further secure their catch, lobster traps have a second compartment that can be accessed from the kitchen. This section is called the "parlor" or, sometimes, the "bedroom." There is another head leading from the kitchen to the parlor that might appear to the lobsters as a means of exit but only lures them further into the trap. This second compartment may or may not be baited.

In these earlier years of the fishery, lobstermen built their own traps, which could be either semi-cylindrical or square shaped. A lobsterman (or his wife) also knitted his own heads and bait bags. Wooden traps are quite susceptible to marine worms and rot caused by the harsh salt water. Add to those factors the battering traps take during the rough conditions of ocean storms, and it is easy to see why traps had to be pulled from the water on a regular basis for repairs or replacement. In Maine, traps were typically pulled during the winter months, during which time fishing ceased while maintenance took place and new heads and bait bags were knitted.

The wooden trap still remains an iconic image of the lobster fishery, found in paintings, sculptures and folk art. Indeed, wooden traps are still in use for fishing in parts of Canada, notably Prince Edward Island and the Isle du Magdeleine or Magdeleine Islands. However, for the most part, the present-day fishery uses traps made of galvanized wire coated with vinyl to prevent rust and leaching of the metal into the water. Wire traps were introduced in the 1970s by James M. Knott. The classic parlor design, with its two knitted heads, remained the same; however, the straps of wood were replaced by a wire mesh. When interviewed by the Lobster Institute, Knott indicated that he started lobstering in the waters off Massachusetts when he was twelve. He found the wooden traps so heavy and unwieldy that he stopped fishing for quite some time. Nonetheless, his early fishing experienced stayed with him, and he knew there had to be a better way. His desire to get back into lobster fishing brought about his invention of the wire lobster trap in 1957. The

One of the most recent pieces of machinery that has found its way onto lobster boats is a tank filled with seawater and outfitted with a recirculating pump to keep oxygen levels up. This gives the lobsterman a means of maintaining the vitality and quality of lobsters caught during the day until they reach the dealers at the wharf. As soon as a lobster is removed from the ocean, it will begin to weaken if not kept in cool, aerated salt water. Without such conditions, the lobster would actually begin to suffocate because it can no longer absorb the oxygen it needs, which is accomplished by drawing it from the salt water passing through its gills. While such tanks would be beneficial for all lobsters, they aren't always essential, and therefore not all lobster boats are equipped with this system. It is, however, particularly useful for lobstermen who have a high number of traps to haul and thus a longer time at sea, as well as those who fish offshore and might be gone for more than a day at a time.

The cost of diesel and gasoline took a sharp upturn in 2009. Since that time, fuel prices have increased 67 percent. This has caused lobstermen to look at ways in which they can trim some of this cost, and as a result there is a growing interest in using solar energy to provide the needed fuel for ancillary equipment such as navigational instruments, radios and tank systems.

Trap Making and Lobster Gear

Back in Captain Weymouth's day, as lobsters were so plentiful, "good and great," all that was needed to catch a lobster was a basic hoop net. As the name implies, this apparatus was composed of a circular hoop made of wood with netting attached to the underside and lines for hauling attached to the top, not unlike a big drawstring purse. This net was then lowered into the ocean in fertile lobster grounds, perhaps with a bit of fish for bait. It was then a matter of waiting for lobsters to cross the net before hoisting them up. It was certainly not the most efficient means of fishing, but it was effective enough in those early days before a true commercial fishery had begun.

It wasn't until the 1850s that lath traps began to replace the hoop nets. Certainly, this method of capturing and then confining the lobster until the trap could be hauled was a much more efficient means of harvesting. Lath traps were most frequently made of strips of oak.

can reach costs of well over $300,000. Jonesport, Beals and Corea still remain major boat-building areas to this day.

Mechanical and Electrical Equipment

The business of outfitting boats with mechanical and electrical equipment is now a significant a part of the lobster industry. The first motors found on lobster boats, at the turn of the twentieth century, were actually converted automobile engines. These were later replaced by true marine engines, either gasoline or diesel powered. This led to better efficiency and economy, greatly lowering fuel costs in the short term and replacement costs in the long run.

Whereas the stars and other visual landmarks were the first navigational "tools," followed by the simple compass, today's lobster boats are well equipped with several electrical apparatus most lobstermen will not be without. These include modernized navigational equipment such as a radar unit (typically a Loran) and a Global Positioning System (GPS) run by satellite. These allow a lobsterman to pinpoint the location where his traps have been dropped, greatly streamlining his return to haul on a later day (usually within two to three days, weather permitting).

Most boats are also equipped with depth finders and fathometers that will allow the lobstermen to distinguish how deep the water is and what type of surface is found below the ocean, be it muddy, hard-packed or rocky. These instruments greatly aid lobstermen in determining how much buoy line is needed, where to place traps for stability and whether it is an area that lends itself to fishing trawls without the risk of entanglement.

Perhaps the most appreciated piece of electrical equipment on board a lobster boat is the marine radio. Citizen band, or CB, radios were the first to be used, followed by the very high-frequency or VHS radios. These provided an invaluable means of summoning help during an accident or crisis at sea. Lobstermen are quick to help one another out in cases of emergency, as they are usually the closest vessels at hand. The radio is also used by lobstermen to communicate with one another, whether about the news of the day, conditions at sea or simply just to break up the monotony of a long day on the water. Today, a cellphone is also a great asset, though not all areas off the coast of Maine have reliable cellphone reception. As more and more cellphone towers pop up from southwest to northeast, coverage will continue to improve in Maine.

A lobster boat sits idle at sunrise. *Courtesy of Bob Bayer.*

his grandfather when he was just a youngster. He reminisced about how his grandfather would surround his wooden boat with sawdust as it sat on its mooring. He would then use an oar to swirl it around in the water so that the sawdust would wick into the boat cracks and crevices and prevent leaking—"at least for a little while."

Before the introduction of fiberglass, wooden boats (just like wooden traps) were hauled out of the water during the winter months for maintenance and repairs as needed. Fiberglass boats made maintenance easier and less frequent. Although one can still find a few wooden lobster boats, most boats today are made of fiberglass.

Boat building is a significant part of the industry surrounding lobstering. Today, a small, basic lobster boat in the twenty-foot range might sell for about $20,000, whereas the larger lobster boats in the forty-plus-foot range

Modern-day hydraulic pot hauler.

instead of single traps. A trawl is composed of several lobster traps roped together in a line across the bottom of the ocean, marked by a single buoy. Trawls can range from two to five traps and sometimes more. The buoy line is attached to the hydraulic hauler, and all traps are pulled up one right after the other. This was an impetus to design lobster boats with open sterns, which allowed for easier deployment of trawls off the back of the vessel, as opposed to single traps, which typically are deployed off the side of the boat.

Fiberglass lobster boats were introduced in the early 1970s, with Arvid and Arvin Young of Corea, Maine, pioneering the change over from wood. It took some tinkering to make the fiberglass boats as maneuverable and easy to handle (or close to it) as their predecessors, but they made up for their early flaws by providing a level of durability unmatched by the wooden boats. One would be hard-pressed to find a wooden lobster boat that did not begin to leak at some point. Ed Blackmore, a lobsterman from Stonington, Maine, who was interviewed while in his early eighties as part of the Lobster Institute's Oral History Project, told a story of fishing with

Downeast-style lobster boat. *Courtesy of Bob Bayer.*

During the years 1885 to 1910, engines began replacing oars and sails in lobster boats. This greatly increased the range and maneuverability of lobster boats and led to several design changes. The forerunner of today's lobster boat design was the torpedo-stern boat crafted by William "Pappy" Frost in the 1920s, exemplified by the *Redwing*. Originally of Nova Scotia, Frost began a boat-building business in Beals, Maine, after World War I. He became known as the "Wizard of Beals."[15] His torpedo-stern boats were longer than either the dory or peapod and had skeg-built hulls (where the hull goes flat into the keel) and squared-off sterns that gave them stability when carrying dozens of traps. These boat styles become known as the Jonesporter or Beal's Islander.[16] Beals became a hotbed of boat builders, with the Beal family leading the way. Alvin Beal, Mariner Beal, Vinal Beal, Riley Beal, Adrian Beal and perhaps best-known Calvin and Osmond Beal all were lobster-boat builders. And all were descendants of Manwaring Beal, who first settled Beal's Island in 1775.[17] The Beals' boat design, following the lead of Frost, soon became known as the Downeast-style lobster boat, a term still in use today.

It was not until the 1950s that hydraulic haulers relieved the lobstermen of the task of pulling up traps by hand. Not only did this allow for more traps to be hauled in a day, but it also made possible the fishing of trawls

A History of Culture, Conservation and Commerce

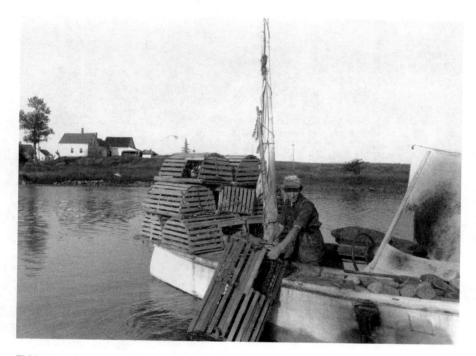

Fishing in a dory the old-fashioned way. *Courtesy of Maine State Archives (via the Lobster Institute).*

twenty-two feet long and powered by sail and oars. It was invented in 1793 by Simeon Lowell, an Englishman who settled in Massachusetts. In those early days, a dory could be purchased for the sum of twelve dollars. The name "dory" came from a species of redfish named John Dory and also known as the "Little Lady of the North Atlantic."[12]

Then, in the 1870s, the peapod was popularized as a lobstering vessel by fishermen from Maine's North Haven Island.[13] According to Joel White of Artisan Boatworks, "Peapods are one of the traditional indigenous small craft of the Maine Coast. They were developed by Native Americans before the arrival of Europeans, for use on salt water, and could be described as a canoe adapted for rough water and heavy carrying capacity, rather than light weight and portability. Originally constructed in the traditional manner using birch bark as a hull sheathing material, Europeans soon adapted them to plank-on-frame construction and for propulsion by oar and sail."[14] Shaped as their name describes, the peapod could easily be propelled in either direction, and this flexibility made it well suited for moving from buoy to buoy.

CHAPTER 4

GEARING UP: ANCILLARY BUSINESSES FROM BOATS TO BAIT AND EVERYTHING IN BETWEEN

The number-one necessity and very first expense for a commercial lobsterman in Maine is proper licensing. Licensing is handled by the Maine Department of Marine Resources (DMR). There are actually three classes of commercial licenses. The Class I license is for a solo operation, with an annual fee of $191. A Class II license, with a fee of $383, allows for one crew member to assist "under the direct supervision of the Class II license holder."[11] A Class III license, with a fee of $565, allows for two crew members to assist the licensed lobsterman. Those under eighteen and over seventy can receive a discount on their licenses.

There are a number of auxiliary businesses connected with outfitting the lobstermen for their quest to land as many lobsters as possible. The economic impact of these industries has not been thoroughly analyzed, but their existence is directly connected to the fishery. If lobstermen thrive, these businesses also thrive.

LOBSTER BOATS

Lobster boats have come a long way from Captain Weymouth's shallops, and lobster-boat building is a crucial part of today's lobster industry.

The mainstay of the lobster fishery through the 1800s was the dory. This flat-bottomed boat with high sides and a sharp bow was typically sixteen to

to overnight shipping across the country, Europe was now within reach of lobster distributors.

Small amounts of lobster could be shipped via regular commercial flights carrying passengers, but the baggage areas were relatively narrow compared to planes designed specifically to carry freight. When the cargo planes that became widely used during the war were introduced to commercial shippers, larger quantities of lobster could be handled much more easily. Then and still today, most cargo planes carrying freight from Maine, including lobsters, fly out of Boston. Boston's Logan Airport is larger and has the infrastructure that shipping by freight requires, making it better equipped to handle cargo planes. The great deal of care needed when packing and handling lobsters to be shipped added special challenges for lobster distributors, but the market of the day could bear the extra expense this necessitated.

After the 9/11 terrorist attacks in New York City in 2001, when commercial aircraft were used as weapons, the Transportation Security Administration (TSA) developed a stringent screening process for companies shipping goods. For lobsters, this meant that dealers had to be able pack lobsters in-house under certain secured conditions that guaranteed no explosives or other harmful items (that could possibly damage an aircraft or harm its passengers) could be packed within their cargo. The cargo must then be dropped off at a TSA-secured destination or any approved airline. Lobster dealers must be inspected and obtain TSA approval as qualified shippers to ensure their cargo will not be held up at the airport for inspection, which could cause untimely delays when shipping live, perishable products. Companies without this certification could end up with losses to the customer in the form of missed flights and losses to their own businesses caused by spoilage and returns.

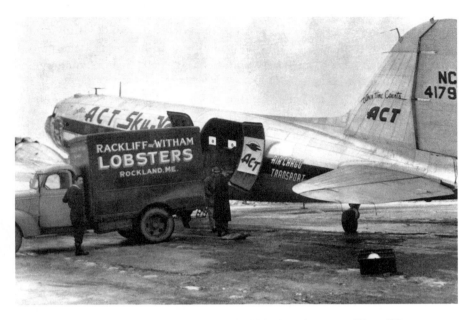

Lobsters being shipped from Rockland. *Photo by Alicia Anstead, courtesy of* Deep Water Magazine *(via the Lobster Institute).*

Modern lobster shipping containers.

cormorants that can find their way into the enclosed pounds. Additionally, while they can feed on food that naturally flows in and out of the pound, the quantities of lobsters held in pounds normally call for supplemental food such as fish-racks to be supplied.

Of course, there is also the risk that too many lobsters will be pounded than future markets might demand. It is not unlike the stock market. You buy at one price, hoping that it will rise in the future and you can cash out for a reasonable profit.

From Sail to Rail

While lobster smacks were bringing live lobsters to markets along the Atlantic coast, the taste for lobster was also spreading inland. This taste was more readily satisfied in the 1870s with the expansion of railroad service in Maine. Railroad companies initially found their way to Maine in 1832, with the first tracks laid between Old Town and Bangor in 1836 by the Bangor and Piscataquis Canal & Railroad. As more tracks were laid, Maine lines could connect with lines to New Hampshire, Boston and beyond. This allowed lobster dealers to pack the live lobsters on ice and ship them to destinations within a two-day journey by steam locomotive.

In addition to shipping lobster out of the state by rail, tourists and a new crop of summer residents (mainly from New York and Philadelphia) could now travel to Maine by rail to escape the crowds and heat of the city. They came in ever-increasing numbers, and lobsters were introduced to a whole new group of eager consumers.

Lobsters Take Flight

Following World War II, commercial airlines began to flourish. Shortly after the war, technological advances in air flight exploded. Lockheed introduced the first pressurized cabin, allowing planes to fly higher and faster. This made transatlantic flights possible. In the 1950s, lobsters took flight. Live lobsters were shipped on ice, packed with seaweed. In addition

Tidal Lobster Pounds Allow for Live Storage

Another early innovation that bolstered the lobster industry was the use of tidal lobster pounds. This was another practice borrowed from Europe and begun in Vinalhaven, Maine, in 1875. Protected ocean inlets were blocked at their mouths by dams engineered to allow seawater to flow in and out with the tides but keep the lobsters placed within from escaping to the open ocean. Pounding of lobsters allowed a lobster dealer to hold live lobsters caught during times of low market demand until the demand increased and the price was higher. Lobster catches are usually greatest in Maine in the fall months, and pounding allows a pound owner to hold lobsters for holiday events like Christmas, Valentine's Day and Mother's Day when people want to celebrate with a special meal.

An additional benefit was the ability to pound soft-shell lobsters, which gave their fragile shells time to harden and their meat yield a chance to increase, thus bringing a better price per pound. The hundreds of lobster pounds found along Maine's coast soon became the mainstay of the industry.

There were and are challenges to pounding lobsters. As the lobsters are basically kept in the wild, they are susceptible to predators like raccoons or

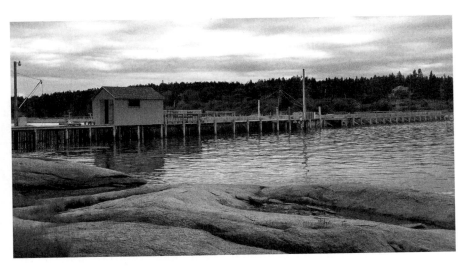

The Heanssler family's tidal lobster pound at Conary Cove in Sunshine, Deer Isle. *Courtesy of Bob Bayer.*

The lobster smack *Silas McLoon* in East Boothbay carried eighteen thousand pounds of lobster in 1913. *Courtesy of the Northeast Archives of Folklore and Oral History, Captain Sydney N. Sprague Collection (via the Lobster Institute).*

was the first Mainer to begin using lobster smacks in the 1830s. From that point on, Maine lobsters were on the move!

Smacks had holes bored through the hulls directly into the holding wells, which allowed for the free circulation of seawater throughout. Live lobsters were loaded directly into these wells and thus could be kept alive for shipping at a very inexpensive price.

Miriam Colwell of Prospect Harbor, Maine, the granddaughter of a lobster smackman, was in her eighties when interviewed in 2003 as part of the Oral History Project conducted by the Lobster Institute. She said she remembers her grandfather sailing his smack filled with lobsters to Gloucester, Massachusetts. She added that they had to be careful to cover their holding wells when it rained because if fresh water were to fill the wells, the lobsters would suffocate. Most smack wells had a hatch cover at deck level. It is said there was a superstition about making sure your hatch cover went on correctly because if it were to be put on upside down, it meant the ship would surely sink.[10]

CHAPTER 3

COMMERCIALIZING THE FISHERY

LOBSTERS ON THE MOVE

The Dutch can be credited with the first big innovation in what was to become a true lobster industry. Following the first recorded lobster catch in Maine in 1605 near St. George's Islands just off Monhegan Island, subsequent records indicate that settlers of the Popham Colony at the mouth of Maine's Kennebec River "gaffed fifty lobsters for food within an hour" in 1607.[8] In colonial times and right up until the 1830s, Maine lobsters did manage to find their way to the Boston and New York markets. A good-sized lobster would sell in the Boston fish markets for a "penny half-penny" or three halfpence.[9]

However, the real start of the lobster industry came about when designs for smacks (or well smacks) found their way from Europe to the United States in the late 1700s. It was in the 1500s that the Dutch first built these sailing vessels with tanks or wells in their holds that filled with seawater. By the 1600s, smacks were being used in England as a means to keep seafood, including European lobsters (*Hommarus gammarus*), alive during trips from fishing grounds to the London markets. Enterprising entrepreneurs in Connecticut mimicked the smack design in the late 1700s. These smackmen were some of the earliest lobster dealers and may or may not have been lobster fishermen. They worked the waters of Long Island Sound initially and then began finding their way up the coast. Elisha Oakes of Harpswell

2002, the Lobster Institute interviewed his grandfather, Robert Joyce, when he was in his eighties as part of its Oral History Program. Robert started lobstering at age eight with his father, Jason's great-grandfather. He told of buying his first boat, a broken-down old skiff, for just one dollar and how proud he was to own his own vessel. It is this spirit of independence and pride that resonates with lobstermen from any region. When asked why they fished, other lobstermen interviewed by the Lobster Institute used words like "pride" and "independence" and phrases such as "…nothing like it," "I wouldn't do anything else" and "I love it."

> *I've lobstered all my life. I like it. As far as I'm concerned, there isn't anything else I'd rather do.*
> —Robert Joyce, Swan's Island

> *If you worked at it, you were successful. If you didn't, you weren't.*
> —Miriam Colwell, Prospect Harbor

> *I can't think of anything that I could have done in my lifetime that I could have been any more happy or contented with than my fishing experience. It was healthy work.*
> —Alison Bishop, Corea

What comes to the minds of most people when they think of the lobster industry are the scenic harbors dotted with lobster buoys and the lobsterman in his oilskin coveralls hauling a trap onto the side of his boat. Then perhaps a trip to a local wharf to pick out a handful of lobsters for a clambake with friends, or maybe a trip to a lobster shack for a casual meal of freshly steamed lobsters. What most people don't realize is that there are thousands of these lobster boats out on the waters of Maine and many thousands more throughout the rest of New England and the Canadian Maritimes that, all combined, land over 200 million pounds of lobster that has to be moved in the commercial marketplace each year. This happens behind the scenes through a complex, multifaceted industry that has a total economic impact well into the billions of dollars. What happens beyond the trap is a blend of time-honored tradition and practices that have evolved over time to bring state-of-the-art technology and global networks to bear in today's lobster market.

Catch of the day in 1938. *Courtesy of Maine State Archives (via the Lobster Institute).*

Captain John Nicolai, Winter Harbor, 2002.

by late afternoon. Maine law has always required that the owner of a lobster boat be the operator of the boat when fishing. Hence, it is still typically a one-man operation, though it can be two or three if the captain has sternmen to help with the baiting, banding of the claws and sorting. Sternmen do not carry their own licenses; rather, they fall under the captain's license. They are not legally allowed to haul traps.

Lobstering entails a long day on the water, often ten to twelve hours or more. It is hard work out in the elements, with lots of time alone with one's thoughts. Thus the persona of the rugged, solitary lobsterman was forged out of the realities of the work and the character of those who make their livings from the sea. Many of today's Maine lobstermen were literally born for the job. Lobster fishing is a generational occupation, passed down first from father to son and now from father to son or daughter. Jason Joyce, who currently fishes out of Swan's Island, is an eighth-generation lobsterman. In

CHAPTER 2

MAINE'S LOBSTERMEN—PROUD AND INDEPENDENT

While lobsters are the centerpiece of the industry, the lobstermen* are its heart and soul. The images of a lobsterman hauling his traps or displaying his catch are as iconic as the lobster itself. According to 2011 records, there were 5,961 commercial lobster-fishing licenses issued but only 4,345 lobstermen fishing in Maine. This leaves 1,616 latent or unused licenses issued. (Because it is difficult to reacquire a license, many fishermen are reluctant to give theirs up even if they aren't fishing.) This number does not include those who fish as sternmen. There are three basic classifications of licenses. Class I is for a single owner/operator, Class II allows for one sternman and Class III allows for two sternmen.

Often a lobsterman's day starts in the early morning hours before sunrise. Not too much of a lobsterman's workday has changed over the centuries. While boats and equipment have certainly been modernized over the years, the routine of loading up with bait, heading out to traditional fishing grounds (first by sail and then by motor) and the routine of hauling traps, sorting the catch and re-baiting and resetting the traps has changed very little. Lobster fishing has remained primarily an inshore or near-shore fishery, with lobstermen setting out in the morning and coming back to the wharf

* Nearly all women who fish for lobster prefer to be called lobstermen, and will honor this colloquialism. According to Maggie Raymond of the Associated Fisheries of Maine, "I don't know anybody who likes that 'fisher' title—the women I know who actually are fishing have no problem being called fishermen."

day harvesting. From every fifty thousand eggs, roughly only two lobsters are expected to survive to legal size.

During the molting process, a lobster will struggle out of its old shell while simultaneously absorbing water, which expands its body size. After molting, a lobster will eat voraciously, often devouring the shell it just shed. This replenishes lost calcium and hastens the hardening of the new shell. This molting, or shedding, occurs about twenty-five times in the first five to seven years until a juvenile reaches adulthood. Following this sequence, the lobster will weigh approximately one pound. After this time, the adult lobster might then molt only once per year or once every two years if an egg-bearing female. At this point, the lobster will increase about 15 percent in length and 40 percent in weight with each molt.

No one has yet found a way to determine the exact age of a lobster (though a promising new technique discovered in 2012 by Dr. Raouf Kilada at the University of New Brunswick is being validated as this is written). However, based on scientific knowledge of body size at age, the maximum age attained might approach one hundred years. Lobsters can grow three to five feet or more in overall body length.[7]

When one hears of lobsters being sold as either hard-shell or soft-shell, this is an indicator of at which point in the growth cycle the lobster was caught and sold. If caught leading up to a molt, the lobster will have a very hard shell. One may even notice that barnacles have attached themselves to the shell. These lobsters will have a higher meat yield by percent of body weight. If caught after a recent molt, the lobster will have a very soft shell and a lower meat yield due to the excess water taken in to aid in the process of shedding. There are several marketing implications related to whether a lobster is a hard-shell or soft-shell, which will be covered in chapter five.

As benthic creatures, lobsters function well in low-light conditions. In fact, they are most active at night, when, as a Mainer might say, "it is as dark as the inside of a pocket." This is when these nocturnal creatures move about more readily in search of food and are most apt to enter the lobstermen's baited traps.

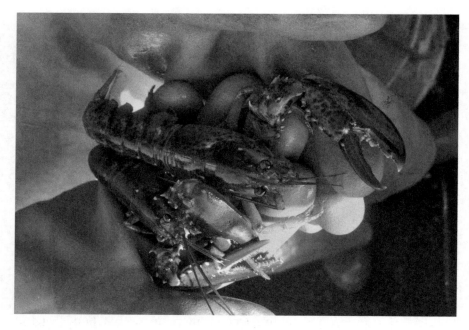
Juvenile lobsters held in a fisherman's gloved hands. *Courtesy of Bob Bayer*.

As a close relative of insects, lobsters have frequently been called "bugs" by fishermen. Like insects, lobsters are invertebrate arthropods. As noted, they have a hard outer "skeleton" and no backbone or spinal column. Both have very primitive nervous systems, and neither insects nor lobsters have brains. Furthermore, lobsters and other invertebrates have only about 100,000 neurons, while humans have over 100 billion.[6]

Lobsters grow from eggs that are carried within a female lobster for about nine months and then are extruded and carried on the underside of a lobster's tail for about another nine months, held in place by a glue-like substance. These eggs are no bigger than the size of a pinhead—approximately one-sixteenth of an inch. When the eggs hatch, they are released from the tail as Stage I larvae. They are so light that for the first two weeks or so, they float in the water column and are very susceptible to predators. They will quickly grow by molting through three stages. After the fourth molt, the few that survive will settle to the bottom and look for hiding places in rocks, grassy areas, etc. Now in the post-larval stage, they will progress through several more molt cycles before venturing out of hiding as juvenile lobsters. It takes five to seven years for a lobster to grow to the legal size for current-

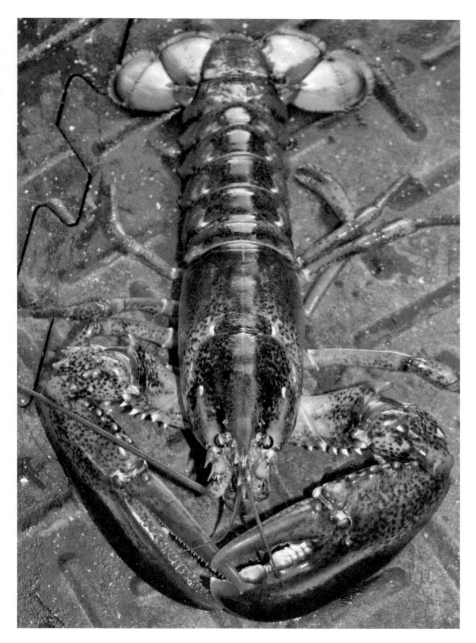

The American lobster, showing the large crusher claw, smaller ripper claw, four pair of walking legs, the carapace and the tail.

Spoilage will spread through uncooked dead lobsters fairly quickly, making them unsafe to eat. This challenge of keeping lobsters alive on their way to market severely limited shipping in colonial days, and thus the markets for lobster stayed rather local for decades.

Homarus americanus: The Centerpiece of the Industry

The centerpiece of what was to become a multibillion-dollar industry is *Homarus americanus*, the American lobster. The American lobster is a cold-water, benthic crustacean—meaning that they are shellfish that dwell on the bottom of the icy oceans ranging from Virginia up through the Canadian Maritimes. There is no other place on earth where you can find *Homarus americanus*. While lobsters can be found in the United States as far south as Virginia, today's commercial fishery really starts in Rhode Island. It runs through the coastal states of New England, with Maine having the most abundant stocks.

Lobsters are aquatic arthropods of the class *crustacea*. As such, they have segmented bodies, chitinous exoskeletons (a hard outer shell with no internal skeleton or bones) and paired, jointed limbs.

Lobsters are classified in the phylum *arthropoda* (which also includes shrimp, crabs, barnacles and insects). The word *arthropoda* comes from the Latin word "arthro," meaning jointed, and the Greek word "poda," meaning foot. This nomenclature refers to the lobster's jointed appendage (claws and walking legs). Lobsters are also decapods, *deca* being Greek for "ten." This term refers to the lobster's ten legs (five pairs), including eight walking legs (pereiopods) and two major claws.

In laymen's terms, the largest claw is known as the "crusher claw." It is used to literally crush prey such as other shellfish like mussels or clams. The smaller of the two claws, commonly called the "pincher claw" or "ripper claw," is pointed and has sharp, jagged edges used for tearing food apart. It is these claws that set *Homarus americanus* apart from most other types of commercially fished lobsters (notably the spiny lobster, *Panulirus argus*, which lives in warmer waters). Many find that the claws and knuckles (appendages leading to the claws) of the American lobster contain some of the sweetest, most tender meat.

thirty very good and great Lobsters, many Rockfish, some Plaise, and other small fishes, and fishes called Lumpes, verie pleasant to the taste: and we generally obserued, that all the fish, of what kinde soeuer we tooke, were well fed, fat, and sweet in taste."[2]

This marked the first recorded catch of the American lobster, *Homarus americanus*. While it is said that the catch by Captain Weymouth's crew was the first recorded lobster catch, it is important to note that Maine's Native Americans were most likely catching lobsters for many years before the *Archangel* found their shores. Indeed, Rosier noted the sailors found evidence of camp fires, egg shells, fish bones and animal bones when they first came ashore.[3] This is further validated by English explorer Thomas Morton, who in 1622 recorded the following observation of lobsters' role in Native American feasts: "This being knowne, they shall passe for a commodity to the inhabitants; for the Savages will meete 500 or 1,000 at a place where Lobsters come in with the tyde, to eate, and save dried for store; abiding in that place, feasting and sporting, a moneth or 6 weekes together."[4]

It has been written that Native Americans used lobsters to fertilize their crops and bait their fishing hooks. They did also eat them, reportedly preparing them by placing them over heated rocks and covering them with seaweed. According to tradition, this cooking method inspired the classic New England clambake.

The crustacean was said to have been so plentiful in those early colonial years that all one had to do was wade into the shallows, reach down and pick up lobsters from the bottom. It is my theory that it was the Native American women who were actually the first to catch lobsters in Maine, by hand or with dip nets. This is because it was more a chore of gathering or harvesting, which was left to the women, rather than fishing or hunting, which were jobs for the men.

Though it is hard to believe in this day and age, when you might pay thirty-four dollars or more at a New York restaurant for a steamed lobster, that due to their great abundance in colonial times, lobsters came to be known as the food of paupers. They were so plentiful and so common that legend has it that indentured servants would even have it written into their contracts that they could not be served lobster more than three times per week.[5]

As the colonies became more settled, trade and commerce grew. Lobster could be found in most markets reaching from Maine to New York. Markets did not extend any farther in these early days of American history. Unlike most other fish or meats, lobster must be shipped and cooked as a live animal. Outside of water and absent refrigeration, a lobster will perish within a day.

CHAPTER 1

SETTING THE SCENE

THE FIRST RECORDED LOBSTER CATCH

The *Archangel*, captained by George Weymouth, set sail from Ratcliffe, England, on March 5, 1605. It was seventy-three long days before the company of twenty-nine men spied land off the coast of what is now the state of Maine. They first made landfall on Monhegan Island on Friday, May 17, and here they replenished their spent supplies of dry wood and fresh water. Two days later, they found themselves off the coast of Maine's St. George's Islands.

James Rosier accompanied Captain Weymouth and kept a written account of his observations. Of the St. George's Islands, he wrote, in the old English of the day, that they had "found a conuenient Harbour, which it pleased God to send vs, farre beyond our expectation, in a safe birth defended from all windes, in an excellent depth of water for ships of any burthen."[1] Here they took respite from their days at sea. Fish was bountiful in Maine's pristine waters, and some of the men set out each day in the vessel's shallop (a small, open boat fitted with oars and sails for use in shallow waters) to catch cod, haddock and other small fish.

It was on Tuesday, May 21, that Rosier reported, "...Towards night we drew with a small net of twenty fathoms very nigh the shore: we got about

industry, which employs hundreds of people in Maine, in other states and at the federal level. With a depletion in groundfish such as cod and striped bass (also known as stripers or rockfish), the lobster fishery remains as the most (if not the only) viable and successful commercial fishery in Maine. Many fishermen who once fished different species depending on the season now go out almost exclusively for lobsters in order to make their livings. With this kind of fishing pressure, and economic pressure, proper management of the lobster fishery is more important than ever.

You can't have good management without good science. Thus the layers of the industry go even deeper. I, for one, know this firsthand, as my job at the University of Maine's Lobster Institute is one of the many that would not exist without the lobster industry. Biologists and ecologists are gainfully employed to study the issue of lobster health and population dynamics. Food scientists are researching product development and food safety. Engineers from many disciplines are looking to find ways to enhance lobster gear and build more economical, user-friendly and environmentally friendly boats.

On the surface, it might seem that very little has changed in the lobster industry over the centuries. Traps are still hauled basically by hand, and the lone lobsterman ventures out into the rugged Atlantic each morning and returns each evening with his catch. Who in the colonial days of Maine, when lobsters were food for paupers and used as corn fertilizer by Native Americans, could have anticipated that the once lowly lobster would become the centerpiece of commerce and a true icon of Maine's coastal communities? And who could have predicted the changes in technology that have impacted boat building, navigation and methods of handling, storing and shipping lobsters? What was once a local market has become an international market. What was once totally unregulated has become a model for sustainable fishing.

Still, in spite of it all, the image of the independent lobsterman, face chiseled by days at sea, is the image that rings true when one thinks of the lobster industry. These fishermen have taken an active role in both growing and protecting their own livelihoods and the industry as a whole. They remain the heart and soul of Maine's coast and a lobster industry that has transitioned seamlessly, at least to the casual observer, into the twenty-first century.

Introduction

Just stop to think, though, about the collective roar of nearly 4,500 lobster boats all heading out at the same time—and the 300 million buoys floating in Maine's waters—and you'll begin to get an idea of the magnitude of the business surrounding the Maine lobster. Yet the lobster trade is much more than just a fishery. It is an extensive, multilayered industry that is far more complex than meets the eye.

Economists have indicated that the true economic impact of the lobster industry goes well beyond the value of the lobsters hauled up in the traps. It is most certainly big business. If you were to consider the number of lobster license holders and their sternmen as being employed collectively by one company, it would be one of the top three companies in the state of Maine. It is the economic trickle down—or up, as the case may be—that pushes the value of the lobster industry into the seven-figure range.

This book will focus more on this aspect of lobster commerce—the many facets of the lobster industry beyond the trap. This amazing crustacean, the lobster, has been around for thousands of years and is the centerpiece of a multibillion-dollar economic force. Though there is no exact count, the number of businesses and workers that rely on a vital lobster resource and a thriving fishery are staggering, and they often seem to operate behind the scenes. We will look at the other major players along the market chain outside of the harvesters: tidal lobster pound owners, dealers, cooperatives, buyers, distributors, processors and food service companies.

We'll also look at some of the less obvious businesses that circle the periphery of the core of the industry. Consider the boat builders, trap makers, marine supply stores, bait dealers, fuel suppliers and others with a direct connection to the work of a lobsterman.

There are also those enterprises that have been built on the fishery but are not as directly connected. A vibrant culture has been built around the lobster and the lobstermen of Maine. Restaurants and inns along the coast have capitalized on the appeal of lobsters and the charm of lobstering communities. There is a plethora of artists and writers who have drawn their inspiration from them as well. The tourism industry along Maine's coast is permanently entwined with the lobster industry. A visit to Maine would not be complete without enjoying a lobster dinner. Many even make the trip with that as their number-one goal.

I would be remiss if I did not include the history of lobster management, which started with the first regulations in 1828 banning out-of-state fishermen from catching lobsters in Maine and spread to size restrictions in the 1870s. Today, this is an integral, if sometimes controversial, part of the overall

Introduction

"If the good lord made anything better than lobster, he kept it for himself." These words were told to a young lad from Stonington by his grandfather. Ed Blackmore grew up to be a lobsterman himself, as well as one of the founders of the Maine Lobstermen's Association and the Lobster Institute at the University of Maine. I certainly do agree—as most Mainers will—with Eddie's grandfather.

Lobster fishing is more than a way to make a living; it is a way of life. It has been intricately woven into the heritage of Maine's coastal communities for generations. The first recorded lobster catch occurred in the 1600s, and it took off as a commercial fishery in the late 1700s. Like Eddie, many of Maine's lobstermen and women recall fishing with their grandfathers, and their fathers tell of fishing with their grandfathers. It's a family business like no other. Secrets of the best fishing grounds, what makes the perfect bait and how to navigate the rocky waters of Maine's coves and inlets have been passed down from generation to generation.

At last count, 144 lobstering villages dot the more than three thousand miles of Maine's coast. These villages are quaint, and their people are hardworking. And to many, the whole package of a lobstering community is the essence of Maine.

The slow, gurgling rumble of lobster boats starting out at 5:00 a.m. to haul traps is a signature sound in every lobstering harbor. Picturesque images of lobster buoys bobbing just outside the harbor are part of everyday life for the fishermen yet also the perfect subject matter for postcards and paintings.

that make up Maine's lobster industry for over thirty-five years. Their indomitable spirit is captured in this book, filled with stories and photos that portray the history of this industry in an entertaining and educational way. Cathy presents this history in a highly readable style and thorough manner that will enlighten the reader to what happens, as she puts it, "beyond the trap."

Dr. Bob Bayer

Foreword

Lobsters are nearly as mysterious today as they have been through the millennia. As a lobster scientist, it continually amazes me how much we do not know (yet need to know) about what makes these creatures tick. What is crystal clear, however, is the fact that they are incredibly delicious and much sought after. As a result, they have drawn countless fishermen to the sea to set their traps in hopes of bringing in a good haul.

Supply and demand has grown exponentially over the decades, giving birth to a multi-dimensional lobster industry. Hundreds of millions of pounds of lobster are moved through the supply chain from the harvester to the consumer every year. Commercial lobster fishing in Maine is an economic powerhouse.

This book tracks the evolution of the lobster industry from the 1600s to the present. It pulls together information on both the intricacies and broad scope of the major sectors and the multitude of ancillary businesses that rely on the lobster for their success. It brings a clear understanding of the linkages that forge the many parts of the lobster industry into a cohesive whole.

I have been working closely with the people and businesses

Dr. Bob Bayer.

Acknowledgements

more than I ever imagined there was to learn about lobster fishing and the lobster industry. Because of them, I am able to share this book with you.

Special acknowledgement also goes to the many knowledgeable resources I drew on in my writing, particularly:

Dr. James (Jim) M. Acheson
The Downeast Lobstermen's Association
East Coast Seafood/Paturel International and Maine Fair Trade Lobster Companies
The Maine Department of Marine Resources
The Maine Lobstermen's Association
The Maine State Archives
The University of Maine Lobster Institute

Thanks to the Boston Red Sox for winning the 2013 World Series Championship while Michelle and I were in Fenway Park.

Above all, I thank Michelle for both the simple things—like making me dinners while I was writing—and all of the most important things, like encouraging me, having faith in me and sharing the best of life with me.

Acknowledgements

My mother, Dolores Welzant Billings, is an amazing woman who raised five children with energy, zest and love. She motivated us to learn more, do more and achieve more—leading us by example. She graduated from college the same year I graduated from high school. She started running with me when I was training to play basketball at the University of Maine and continued long after I stopped to run a marathon at age sixty. Her inspiration has guided me through life and certainly through tackling the challenging task of writing this book. Thank you, Mom.

Thanks to all of my sisters and brothers, whom I admire more than they will ever know.

Sincere thanks also to Dr. Bob Bayer—a good friend and the best boss ever! Bob is the executive director of the Lobster Institute at the University of Maine, and we have worked together for fourteen years. He's a creative researcher, an innovator and a well-respected colleague of lobstermen and scientists alike. When I first started working at the institute, the only thing I really knew about lobsters was that they tasted great with melted butter. Bob has been a great mentor and has given me the opportunity to learn so much about the lobster industry. Though it might seem cliché, this book certainly would not have been possible without him.

Of course, a genuine thank-you to the many lobstermen, pound owners, processors, distributors and marketers I have met through my experiences with the Lobster Institute. They have shaped my perceptions and taught me

Contents

5. Accolades and Innovations Expand the Market	47
From Ordinary to Extraordinary	47
Canning Helps Meet the Demand	48
Lobster Gains a Worldwide Reach	51
6. Getting from the Lobstermen's Traps to Your Table: Who Is Handling Your Lobster?	55
Lobsterman to Dealer	55
Co-ops and Other Options	57
Hard-Shell or Soft-Shell	60
Live or Processed	61
Processed to Plate	65
7. Imports and Exports: The Canadian Connection	68
8. Sustainability: Conservation Before Conservation Was Cool	72
The Co-Management Model	72
Managed for Sustainability	75
Is It Fishing, or Is It Farming?	83
Hatcheries and Habitat	84
Certified as Sustainable	87
9. The Science of Lobsters: Researchers and Regulators	90
10. Marketing: A Taste of Maine	101
11. A Cultural Icon, a Community Heritage	106
Experiential Tourism	106
Everything from Trinkets to Treasure	112
Notes	117
Glossary	121
Index	125
About the Author	128

Contents

Acknowledgements	7
Foreword, by Dr. Bob Bayer	9
Introduction	11
1. Setting the Scene	15
The First Recorded Lobster Catch	15
Homarus americanus: The Centerpiece of the Industry	17
2. Maine's Lobstermen—Proud and Independent	21
3. Commercializing the Fishery	24
Lobsters on the Move	24
Tidal Lobster Pounds Allow for Live Storage	26
From Sail to Rail	27
Lobsters Take Flight	27
4. Gearing Up: Ancillary Businesses from Boats to Bait and Everything in Between	30
Lobster Boats	30
Mechanical and Electrical Equipment	35
Trap Making and Lobster Gear	36
All About Bait	44

To my mother, for her inspiration and love.